Louisville

REMEMBERED

Louisville

R E M E M B E R E D

G A R Y F A L K

THE
History
PRESS

Published by The History Press
Charleston, SC 29403
www.historypress.net

All images are courtesy of the author's private collection unless otherwise noted.

First published 2009
Second printing 2013

Manufactured in the United States

ISBN 978.1.59629.628.2

Library of Congress Cataloging-in-Publication Data

Falk, Gary.
Louisville remembered / Gary Falk.
p. cm.
Includes bibliographical references.
ISBN 978-1-59629-628-2
1. Louisville (Ky.)--History. 2. Louisville (Ky.)--Biography. 3. Industries--Kentucky--
Louisville. I. Title.
F459.L857F35 2008
976.9'4404--dc22
2008055293

Contents

Acknowledgements 7
Introduction 9

PART I. Defining Personalities 11
PART II. Industrial Achievement 45
PART III. The Physical Landscape 83
PART IV. Character of the City 125

Appendix: Candy Manufacturers in Louisville and Southern Indiana 151
Bibliography 155

Acknowledgements

I wish to thank the many individuals who have offered assistance, some with specific suggestions and counsel, others with their support and camaraderie.

First of all, I am grateful to the late George Yater. His book *Two Hundred Years at the Falls of the Ohio* remains the definitive single volume of our local history.

Being part of the Louisville Historical League has been a defining aspect of my life. This organization is made up of a who's who in pursuing, protecting and documenting the history of Louisville and southern Indiana: Steve Wiser, architect and president of the league, whose book *Louisville 2035* offers insights on the Louisville of the future; Rick Bell, author of *The Great Flood of 1937*; Chuck Parrish, who literally "wrote the book" on the history of the Portland Canal and the McAlpine locks and dam project revision; Ken Machtolff, Walter Hutchins; Mike Zanone; and archaeologist Lori Stahlgren.

In addition, thanks go to Jim Holmberg, curator of Special Collections at the Filson Historical Society; Bill Carner at the University of Louisville Photo Archives; Tom Owen, Louisville historian; Joe Hardesty at the Louisville Free Public Library; and John Kleber, editor of *The Encyclopedia of Louisville*. I am grateful to my wife, Dorissa, without whose able moral support, proofreading and assistance this would not have been possible.

Introduction

There are stories within stories in the urban history of a city. Many of the most fascinating tales about our city of Louisville are still waiting to be rediscovered.

This process of discovery has been my motivation since I started writing a series of articles in 2004 entitled "Looking Back" for the monthly publication of the Louisville Historical League, *The Archives*. These articles form the basis for this book.

To be certain, much of Louisville's history has been carefully chronicled since the founding of the city. The westward migration, the Lewis and Clark Expedition, the importance of the Falls of the Ohio and many of the essential players, such as George Rogers Clark, Thomas Bullitt, Richard Chenoweth and others, have received serious attention. James Guthrie, sometimes referred to as "Mr. Louisville," was pivotal in helping Louisville become the metropolis that it is today. Important families such as the Speeds and the Binghams have received well-deserved attention.

Much of this history has culminated in the essential publication entitled *The Encyclopedia of Louisville* (University of Kentucky Press, 2001, John Kleber, editor), which should be the centerpiece of any library dedicated to Louisville's history.

My hope and expectation is that I may acquaint the reader with some of those "stories within stories" of this city that might otherwise have gone unnoticed.

PART I

Defining Personalities

CHARLES K. CARON, INVENTOR OF THE CARON DIRECTORY

To genealogists, urban researchers and businesses, the Caron city directory is a valuable asset in searching for information about the urban landscape and the persons and things contained in it.

Since 1871, the Caron directory has been a powerful tool in our city of Louisville; it chronicles who lived where and when, what businesses existed and where they were located and also tells us about the advertising of each period, since it is the advertising—placed there to pay for these directories—that unwittingly helps to tie all of this information together. The directory offers cross-references for us to locate residential, government and business locations.

The Louisville Caron directory was the invention of Charles K. Caron. It was originally published at 104 West Green Street (Liberty), the same physical location that today is 316 West Liberty. Mr. Caron died in 1903, but the directory was continued by his coworker Stephen D. Smith and Caron's sons, Charles L. and L.S. Caron. They expanded the shop to serve other businesses, requiring a specialty of linotype composition—printing catalogues, newspapers, magazines and briefs. The company was eventually able to expand to other cities. The Louisville publishing house printed directories for Paducah, Frankfort, Hopkinsville, Winchester, Henderson and Maysville, Kentucky, along with many Indiana towns, including New Albany, Bloomington and Jeffersonville. Xenia, Ohio, was even included.

Eventually, the publisher moved to a new plant located at 127 South Third Street.

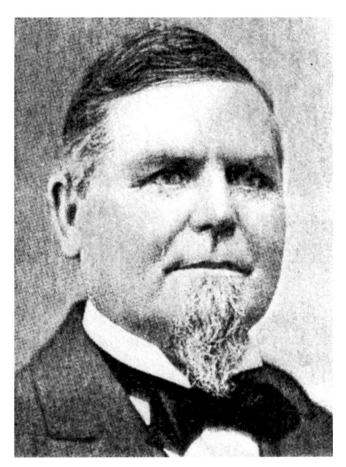

Charles K. Caron.

The Caron directory of Louisville remained under the Caron name until around 1975, when it became part of Polk and Company, which is located in Taylor, Michigan. The city directories still remain a major research tool for historians. The crisscross address feature, just like the crisscross directories themselves (since 1939), offer a relatively easy way to trace property lineage.

CHARLES FARNSLEY—LOUISVILLE'S "THREE-TIME" MAYOR

Louisville has a long history of mayors who have left an enduring legacy. The original charter of the city allowed an election to be held for mayor with the top two candidates being presented to the governor, who would then

The spine of a Caron directory.

Left: A caricature of Charles Farnsley. *Courtesy of* Reader's Digest.

Below: Charles Farnsley—the only mayor, to this day, sworn in for a third time. His father, Judge Burrell Farnsley, administers the oath.

choose between them for a one-year term. Our first mayor—ship owner and member of the Rhode Island militia, John Bucklin (1828–34)—was chosen to serve six one-year terms. Eventually, mayors were elected for a single four-year term but could not succeed themselves.

Charles Farnsley, deemed by some to have been our most colorful mayor, became something of an exception to the rule. Farnsley was elected to the Kentucky House of Representatives in 1935 and reelected in 1937. He was elected by the board of aldermen to fill the unexpired term of Mayor Edward Leland Taylor. Taylor died of a heart attack in February 1948, halfway through his term. Farnsley was then elected by popular vote to serve out the remaining two years. In November 1949, he was elected to a full four-year term. His father, Judge Burrell Farnsley, had the distinction of administering the oath all three times. In 1965, he was elected to the U.S. House of Representatives from the Third District of Kentucky, defeating the incumbent, Gene Snyder. He served until 1967 and did not seek reelection.

Charles Rowland Peaslee Farnsley was born in Louisville on March 28, 1907. He graduated from Male High School and studied political science at the University of Louisville. He received his law degree from the latter and

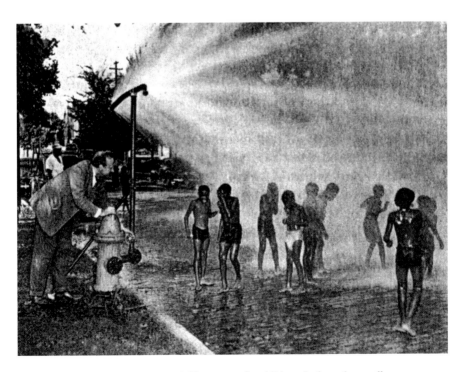

Mayor Farnsley turns on a new sprinkler system for children during a hot spell.

entered the practice of law in 1930, joining his father's law firm. He entered politics soon thereafter. He claimed throughout his career that he was guided in his public life by his love of both Confucius and Thomas Jefferson.

From the removal of trolley tracks to controlling traffic patterns on major roads, the weekly "beef" sessions every Monday night at city hall, the carrying of a musket to the Confederate statue on Third Street to "protect" it and ultimately becoming president of the Filson Club (Filson Historical Society) in 1979, Charles Farnsley added a certain spice to the life of Louisvillians.

As mayor, Farnsley was successful in getting legislation passed that permitted Louisville to benefit from a 1 percent occupational tax on all payrolls in the city of Louisville. Revenue from this tax was judiciously used for many city improvements, including repaving vast amount of roadways. Farnsley managed to have certain areas set aside for children to play. "Tot-lot" playgrounds were provided. A force of female traffic officers was established to serve at street crossings used by schoolchildren.

A notable achievement of the Farnsley administration was the creation of the Louisville Fund, now known as the Fund for the Arts. This was originally a funding source for the orchestra but became an umbrella organization to cover all facets of the performing arts.

The Louisville Free Public Library benefitted greatly under the Farnsley administration. While Farnsley was mayor, the library became desegregated. The library radio station, WFPL, was created with the help of Charles Farnsley. The idea was to create a classical music noncommercial format.

Farnsley had the good fortune to have feature articles in two leading national publications written about the whirlwind that he created when he took office. The May 21, 1949 issue of *Collier's* magazine featured an article on Farnsley entitled "Confucius in Louisville," written by Richard B. Gehman. "Here's a Mayor Who Knows How to Get Things Done," by George Kent, was in the November 1949 issue of *Reader's Digest*.

Were he alive today, Charles Farnsley would be pleased with one facet of local government—the fact that we now have county-wide Metro government. In an interview in 1975 with Charles Harbison, he complained that the "fringe" (by which he meant the areas outside the city) contributed little to the city while receiving many of its services. This was compounded by the fact that shopping centers were being built outside the city limits, drawing needed revenues away from the city.

Charles Farnsley died on June 19, 1990. He and his wife, Nancy Hall Carter Farnsley, are buried at Cave Hill Cemetery.

Captain Daniel Parr and the Contested Will

Steamboat captain and Louisville investor Daniel G. Parr was born in Alsace-Lorraine, France, on February 12, 1825. After moving to America, he became very successful up and down the Ohio River as a steamboat captain and owner, and he made many investments in Louisville properties.

Seeing an old woman, poorly clad and sick, made an impact on Parr. "A refuge which would make unnecessary such suffering as that woman would be worth a hundred Carnegie Libraries," he said. He set out to do something about this concern. In the late 1800s, he helped build a facility at 928 South Third Street in Louisville. Later, he was the principal benefactor in the construction of the home Parr's Rest, named after the famous captain. The home opened on December 21, 1909, at Highland Avenue and Cherokee Road. The building was quite spectacular for its time.

The Elizabethan and modified Gothic architecture was quite an attraction. The cost of the new structure was about $90,000. Entering the front door, one stepped into a spacious lobby with a high ceiling supported by pillars. The building was complete with a sun parlor and a well-appointed dining room that could accommodate one hundred persons. The second and third floors contained most of the rooms for the "matrons." Like many buildings of its time, the facility was said to be "absolutely fireproof," a claim that soon wore thin when the "absolutely fireproof" Iroquois Theatre in Chicago became engulfed in flames one month after it opened in 1903, killing over six hundred patrons.

The only requirement for occupancy was that a woman be at least sixty years old, be a resident of Kentucky and have no means of support. Needless to say, the waiting list was long for the hopeful residents at the new Parr's Rest.

Captain Parr died on January 19, 1904. On February 13 of that year, his will left $400,000 in personal property and, after the death of his last grandchild, $450,000 toward the establishment and maintenance of Parr's Rest, the refuge for old and infirm women.

For the next twenty or more years, the will (dated October 7, 1901) was contested, culminating in a lawsuit from Parr's daughter, Mrs. Birdie Parr Marshall, representing herself, a sister (Jennie) and a brother (Willie). Mrs. Parr presented a will administered on October 10, 1903, which, she claimed, left the entire fortune (totaling several million dollars by the mid-1920s) to the Parr children. Mrs. Marshall even had the second will inscribed in its entirety on a marble shaft over his grave in Cave Hill Cemetery. The second

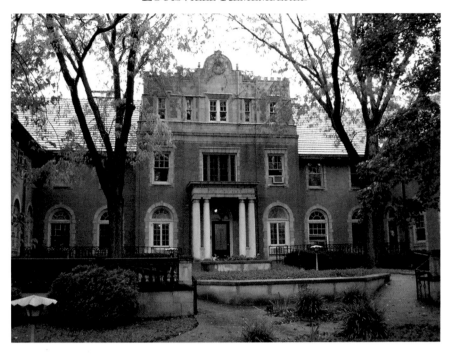

Parr's Rest.

will was written in Daniel Parr's own handwriting and signed by witnesses. On December 14, 1928, in a divided ruling, a Frankfort appeals court affirmed the ruling setting the 1901 will aside.

After all the litigation was completed, little was known about the final settlement. Obviously the Parr's Rest home remained a viable part of the Highlands area of Louisville for another seventy-four years.

Parr's Rest, now open to men and women, became part of the Baptist Homes, Inc. facility in 2002 and is now located at 3101 North Hurstbourne Parkway in Louisville. It is referred to as Parr's at Springhurst.

The Parr's Rest building was recently sold to the Highland Presbyterian Church just adjacent to it on Cherokee Road. The church uses it for its refugee ministry and other church functions. They are doing an excellent job restoring the building, keeping intact much of the original architecture that was envisioned by Captain Parr. It most recently received attention as a sanctuary for persons who lost their homes due to Hurricane Katrina.

BRUCE HOBLITZELL, "MR. HOBBY"

Bruce Hoblitzell was born in Louisville on June 25, 1887, the son of Bruce and Jane A. (Bradley) Hoblitzell. He graduated from the Kentucky Military Institute in Lyndon in 1905 and Manual High School in 1907.

Known as "Mr. Hobby," Hoblitzell wore many hats during his long life in the city of Louisville. In 1919, he started Bruce Hoblitzell Realtors and Insurance Agency. He served as president of the Louisville Board of Trade, the Louisville Chamber of Commerce and the Better Business Bureau. He was also president of both the Louisville and Kentucky Real Estate Boards and served on the boards of the Metropolitan Sewer District and the Louisville Gas and Electric Company. Bruce Hoblitzell was inducted in 2003 into the ranks of distinguished alumni of Manual High School.

He was elected sheriff of Jefferson County in 1953. While serving as sheriff, he worked to keep those incarcerated for public drunkenness for a longer period of time to allow for some degree of rehabilitation. He saw this as a huge problem and an expense for the city to keep the revolving door spinning with the same repeat offenders working through the system. One man had been arrested here 307 times for habitual drunkenness. The problem became so acute that one deputy insisted that the jail had become the "permanent mailing address" for

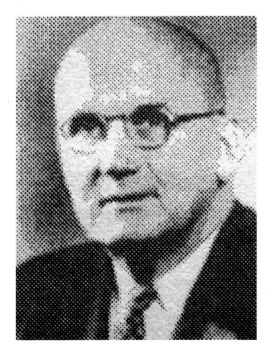

Bruce Hoblitzell.

some of the residents, some even having their Social Security checks mailed to the jail. If any had already been released, they always knew to drop by to pick up their checks! Hoblitzell's idea was to offer longer jail time and vocational training to help with "transitioning" back into the community.

On November 5, 1957, he was elected mayor of Louisville on the Democratic ticket, defeating Republican Robert B. Diehl. He succeeded Mayor Andrew Broaddus. Known for his frugality, Hoblitzell managed to get the state and county governments to take on functions that had previously cost the city more than $2 million a year. These included the county assuming a larger portion of the poor relief burden and having county government pump an additional $400,000 a year into the city/county board of health. The state took over the hospital care of tuberculosis patients at the Waverly Hill Sanitarium. Hoblitzell saw to it that no new city bonds were authorized while he was mayor. Strengthening the city's financial position was undoubtedly his greatest achievement as mayor.

He was very proud of making himself available to discuss issues with Louisville citizens. Under his administration, resurfacing streets and building new roadways was a priority. Two hundred acres of new parks were added to the city during his administration. He also worked to improve race relations in the city.

Each Sunday afternoon, Hoblitzell spent time at the Kosair Crippled Childrens Hospital to play with the children—one of his favorite activities. He was known as a big bearlike man who loved to call one and all "Honey," even men.

Bruce Hoblitzell was succeeded as mayor in December 1961 by William O. Cowger. He was married for sixty years to the former Irene Oatey Forbes. They had one son, Bruce Jr., and two daughters, Jane and Margaret. They were longtime members of Highland Presbyterian Church and for many years lived at 1415 St. James Court in what is now called "Old Louisville." Hoblitzell died at his home on August 11, 1970, and is buried at Cave Hill Cemetery.

GEORGE YATER, A TRIBUTE

When it comes to Louisville and southern Indiana history, one individual quickly comes to mind. George Yater earned the respect of all who loved the history of this area. He was a lifetime member of the Louisville Historical League and was the 1992 recipient of the Founder's Award issued by the league. This award is given to those persons who epitomize lifetime achievement and dedication to the cause of preservation awareness, education and community involvement that has enriched the metro area.

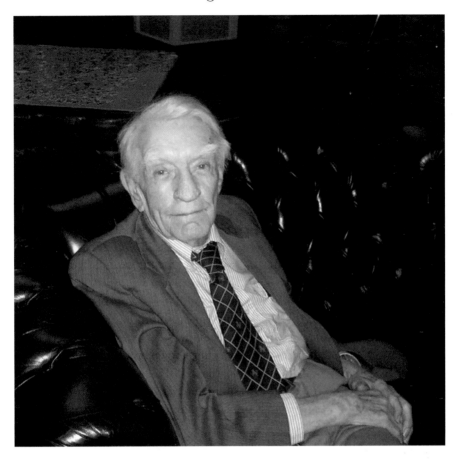

George Yater, Louisville Historical League member and associate editor of *The Encyclopedia of Louisville*.

George Yater was associate editor for *The Encyclopedia of Louisville*, which was published in 2001.

I had the good fortune to interview Mr. Yater on December 11, 2004, at the Treyton Oak Towers here in Louisville.

George Yater was born August 15, 1922, in Louisville. His first home was near Heywood and Fourth Street. His father worked for the L&N Railroad, which probably gave impetus to Yater's lifelong love for trains and streetcars. At a very young age, his family moved to the Beechmont neighborhood, where they lived on Kenwood Way. Yater recalled with fondness growing up in this south Louisville neighborhood and especially the Saturdays when he would attend a local theatre, the "Cozy" on nearby Third Street near Central Avenue. One of his closest childhood friends was Dick Durlauf, who

would later become well known as a musician and owner of the Durlauf Music Shop.

His early education started at Beechmont Elementary School and Holy Name Elementary, then at Saint Xavier High School, which was located on Broadway at that time. He then attended the University of Louisville. When World War II started, he enlisted in the army and was sent to the CBI (China, Burma and India) theatre, where he was active with the Signal Corps. At the end of the war, he was able to continue his education on the GI bill, graduating from the University of Louisville with a degree in history. He received a master's degree in history from Columbia University in New York City.

Career-wise, he began working as a copy boy for the *Louisville Times* while still attending the University of Louisville. This was a job that would turn him toward a lifelong career and love for journalism. He graduated from copy boy to reporter, eventually becoming head of the New Albany bureau of the *Courier-Journal*, where he spent most of his career.

After a long career with the *Courier-Journal*, Yater worked for a period of time for an insurance magazine and then as a feature writer for the chamber of commerce (now Greater Louisville, Inc.) for its *Louisville* magazine.

Perhaps his greatest contribution to local history is his authoritative text *Two Hundred Years at the Falls of the Ohio*, which was nearly a two-year effort. Yater explained that this book and the many feature articles he wrote for the chamber were his two greatest achievements.

An important contribution given by George Yater is his donation of over two hundred stereo card views, photographs, slides and negatives from around 1890 through the 1900s to the University of Louisville. These cover an important period of Kentucky history.

Asked about his pastimes, Yater said that he has a great love for the history of Fontaine Ferry Amusement Park, where he spent a great deal of his childhood. He enjoyed telling about his many experiences in the park and of the various rides that were there.

Besides local architecture and historic preservation, Yater also had a great passion for the railroad, trolleys and streetcars, having accumulated quite a bit of information on the subject, which could someday culminate in some form of written text.

Mr. Yater felt that, in general, we were currently doing a good job restoring and saving local architecture but that twenty-five or thirty years ago this was not the case. There was a period of time in which the trend was to tear down and replace.

Louisville was fortunate to have George Yater. His many accomplishments have secured him a place in Louisville history. He died January 25, 2006.

Defining Personalities

A special area has been set up in the new Ekstrom Library annex at the University of Louisville to house the vast collection of historical documents and research papers that were donated by George Yater when he moved from his home on Tyler Parkway to the Treyton Oak Towers.

THOMAS FOUNTAIN BLUE—FATHER AND SON

Senior 1866–1935
Junior 1926–2007

Walking along the downtown streets of Louisville, one was certain to encounter—sooner or later—Mr. Thomas Fountain Blue Jr., who traveled throughout our city on foot and only occasionally on public transportation. Mr. Blue was a man on the move.

This gentleman was one of the more colorful residents of our city. He was active in the arts, a volunteer usher at the Kentucky Center for the Arts and a mainstay in Mensa, a group of scholars with chapters that crisscross the United States. The Blue family and Thomas Blue Jr. represent an important part of Louisville history, beginning with his father's move here in 1899. On March 12, 2004, I interviewed Mr. Blue in the lobby of the Kentucky Center for this article. He spoke at length about growing up in Louisville, his love for classical music and the arts and his father's many talents.

Thomas Blue Sr. was educated at the Hampton Normal and Agricultural Institute in Virginia. He came to Louisville from Farmville, Virginia, in 1899 to direct the Negro YMCA. In 1905, he was chosen to head the Negro Library (the Western Colored Branch) in Louisville, a Carnegie Library located at Tenth and Chestnut Streets, which remains open to this day. In 1914, he was instrumental in the opening of an east end branch (also a Carnegie facility) at Hancock and Lampton Streets. Mr. Blue played a key role in the training and tutelage of black librarians throughout the South during the period of segregation. He was active in both the American Library Association and the Negro Library Conference.

Among his various other talents, Thomas Blue Sr., who also held a divinity degree from Richmond Theological Seminary, was well known as a minister in Louisville, preaching from many pulpits. Thomas Jr. relates that his father would never accept a special "offering" for his services and only received compensation if it were provided as part of standard church procedure. From the time that he moved here from Virginia, determined that he would

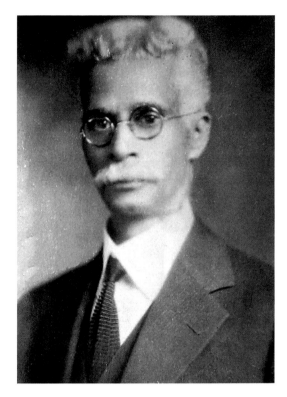

Thomas Fountain Blue.

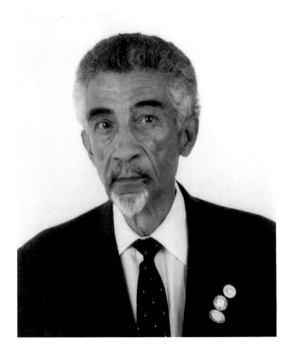

Thomas Fountain Blue Jr.

provide for his family, he began to purchase real estate, beginning with his first home in the 1700 block of West Chestnut Street. In all, Mr. Blue owned six homes in addition to the one he lived in.

Cornelia Phillips Johnson Blue, wife of Thomas Blue Sr., was active in the 1930s in PTA, the Girl Scouts, Youth Speaks and the old YWCA on Sixth Street.

Born in Louisville on September 16, 1926, Thomas Jr. graduated from Central High School in 1943, attended Morehouse College in Atlanta, Georgia, and graduated from the University of Louisville (then known as the Louisville Municipal College) in 1949 with a degree in mathematics. He was one of the first African Americans to enroll in Speed Scientific School (October 1950). He later moved to Cleveland, where he was employed at Smith Electronics, working on a Voice of America contract dealing with antennas and communication systems. He researched high-frequency wave propagation with respect to the ionosphere. Thomas Jr. was one of the few minority members of the intellectually based Mensa organization, where he was influential in its national conventions for nearly forty years.

JENNIE BENEDICT

Much has been written about Jennie Benedict and her famous restaurant and catering business. This famous Louisville lady was quite versatile and important to this community.

Jennie Carter Benedict was born in Harrods Creek, Kentucky, on March 25, 1860. Her family had a wholesale business in molasses and other staples. By the age of six, she displayed an affinity for the culinary profession and for catering parties and events. This was the genesis of a career that lasted more than thirty-two years and spanned many cities in the Midwest, especially Louisville and St. Louis.

She first entered business at her home at Third and Ormsby in 1893, in a kitchen that was built behind the residence. She sent out five hundred circulars to friends, offering to "take orders, from a cup of chocolate to a large reception, sandwiches on short order, cakes large or small, trays and dainty dishes for the invalid." The business quickly grew.

Her first store and catering enterprise opened on May 1, 1900, along with partners Salome E. Kerr and Charles Scribner at 412 South Fourth Street. In 1911, a new "Benedict's" restaurant opened at 554 South Fourth Street. It was a beautiful establishment with many amenities, including an elegant soda fountain made from the rocks of Mammoth Cave. The interior

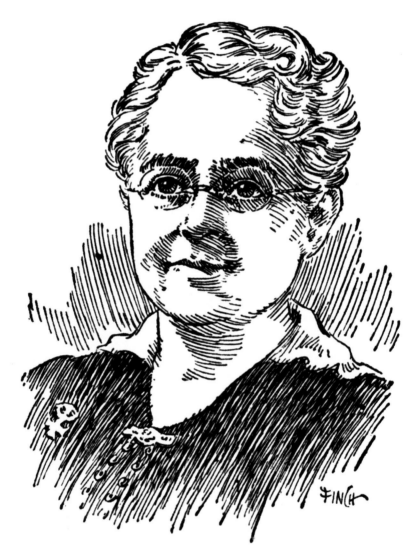

Miss Benedict

Jennie Benedict. *Courtesy of the* Louisville Times.

equipment "comprised electric and gas lights, electric fans, and all those dainty accessories that are so pleasing and gratifying to the eye." Sixty-five employees were required to operate the catering and restaurant operation, which included the creation of fine confections, candies and ice cream.

In 1923, she was given an opportunity to move her business to St. Louis, where she had been doing catering work. As attractive as the proposal was, Jennie was overwhelmed at the response of the citizens of Louisville to remain here. A committee of the retail business association was formed and, in an unprecedented move, collectively presented her with a letter saying that "Louisville can ill afford to lose a citizen like you, one who has always been a leader in every civic and social movement and who has always stood for the advancement of its commercial interests. The name of Jennie C. Benedict & Co. has radiated to all parts of our country the name of Louisville." After careful consideration and quite overwhelmed by the response of local citizen groups, she decided to remain in Louisville and continue to give them the "very best that can be had."

In 1925, Jennie sold her business for $50,000. It was remodeled into a Spanish theme but continued to bear her name for a number of years. She remained active in her many charities, including King's Daughters Home, the Woman's Club of Louisville and other organizations. For a

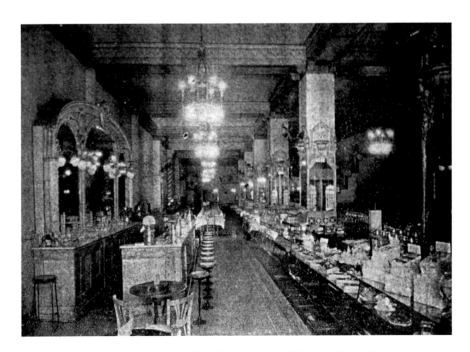

Benedict's Restaurant. *Courtesy of the R.G. Potter Collection, University of Louisville.*

time, Miss Benedict acted as editor of the household department of the *Courier-Journal*.

She retired to her estate in Indianola, Dream Acre, overlooking the Ohio River on a bluff near Mellwood Avenue. She wrote an autobiography entitled *The Road to Dream Acre* (published by the *Courier-Journal*). Jennie Benedict died on July 24, 1928. She is buried at Cave Hill Cemetery.

A historic marker for Jennie Benedict has been placed at 1830 South Third Street in Louisville by the Kentucky Historical Society.

Jennie is best remembered for her classic recipe for Benedictine sandwich spread. Surprisingly enough, it is not included in her famous cookbook, *The Blue Ribbon Cook Book*, which was published by Louisville's Standard Printing Company in 1904:

BENEDICTINE SANDWICH SPREAD

6 ounces cream cheese
Grated pulp of 1 medium, peeled cucumber
1 small grated onion
Dash of Tabasco
1 saltspoon salt, or more to taste
Mayonnaise
2 or 3 drops green food coloring

Mash the cheese with a fork and work in the cucumber, which has been squeezed fairly dry in a napkin. Add onion, Tabasco, salt and enough mayonnaise to make a smooth spread. (Miss Jennie used homemade mayonnaise of lemon juice, olive oil and egg yolks.) Add enough food coloring to give a faint green tinge.

This recipe can be varied to taste and can also be made in a blender, a kitchen gadget unknown to Miss Jennie.

ABRAHAM LINCOLN AND JOSHUA FRY SPEED: A COMPLEX RELATIONSHIP

Controversy abounds about the enduring relationship between Louisville's Joshua Fry Speed and Abraham Lincoln. Speed has been referred to as "Lincoln's most intimate friend" and by Lincoln himself as "a friend forever." The two met in Springfield when Lincoln arrived from New Salem, Illinois, in April 1837. When Lincoln came to the general store of A.Y. Ellis and

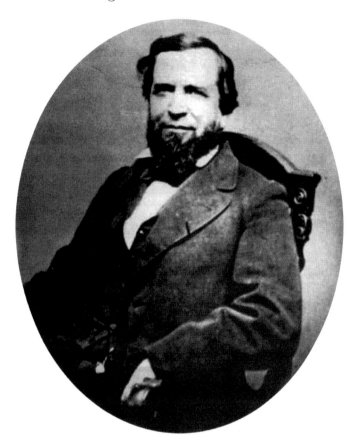

Joshua F. Speed,
"Lincoln's most
intimate friend."

Company, where Speed was a partner, they became fast friends. Much of the dialogue that persists to this day centers upon the offer by Speed to share his double bed with Lincoln, creating a domestic relationship that persisted some four years, ending when Speed moved back to his family home at Farmington outside of Louisville.

Going beyond friendship and camaraderie into a romantic or homosexual relationship is a difficult case to make. Much has been written on both sides of this issue, but establishing a solid basis of documentation is difficult. Much of what you read reflects the bias of the author, since little is revealed in manuscript or correspondence by either of these men. In reading through the twenty or so letters written by Lincoln to Speed, author C.A. Tripp, in his book *The Intimate World of Abraham Lincoln* (Free Press, December 2004), fails to make a *definitive* case for their having a romantic affair, although he does cite instances in which Lincoln slept in the same bed as other men besides Speed, even in the White House when his wife, Mary Todd Lincoln,

was away. Much of what is said or assumed must be kept within a cultural context, with consideration of the period and what daily life was really like.

It is certainly well established that both of these men had satisfactory relationships with women. Joshua Fry Speed was married to Fanny Henning, whom he met after returning to Louisville. Abraham Lincoln had a tumultuous but lengthy relationship with his wife, Mary Todd Lincoln, who was from Lexington, Kentucky, and they had four sons. Author Andrew Ferguson (senior editor of the *Weekly Standard*), in his soon-to-be-released book *Land of Lincoln* (Grove/Atlantic), claims that he has made a case for Lincoln having been something of a ladies' man. This should make for some interesting reading.

In so many important ways, the Lincoln and Speed relationship was a vital one. Both men would seek the council of the other in matters concerning the difficulties of their lives. Speed would receive advice on many legal issues, and Lincoln was interested in matters key to his personal life and his political philosophy. After Joshua Speed's death in 1882, the *Freeborn County Standard* newspaper (Minnesota) reported, "During Mr. Lincoln's administrations, Mr. Speed spent much of his time in Washington where, though he did not sit at the council table officially, he had much more influence, through his prudence, clear-sightedness and practical ability, with the Executive than any other one man." Speed was never interested in an "official" position within the Lincoln presidency, and his talents were directed toward marketing, real estate and social issues (although he did serve one term in the Kentucky legislature). His brother, James Speed, whom Lincoln met at Farmington, served as attorney general in Lincoln's administration beginning in November 1864. The two brothers were pivotal in keeping Kentucky (particularly Louisville) neutral during the Civil War.

After Lincoln was assassinated, sixty members of the Speed family gave money for a monument to honor Lincoln in Springfield. Joshua Speed also wrote lengthy letters to William Herndon, a former law partner of Lincoln, who was writing a biography of Lincoln.

MOSES PRESTON—LOUISVILLE PHOTOGRAPHER

A curious article written by Sherley Uhl appeared in the *Courier-Journal* on July 13, 1941, entitled "Broncos, Deserts and G-Men Can't Stop This Camera Addict."

Moses Preston was a Pullman porter who had a great love for photography. His one-man exhibit at the Lincoln Institute on Shelbyville Road consisted

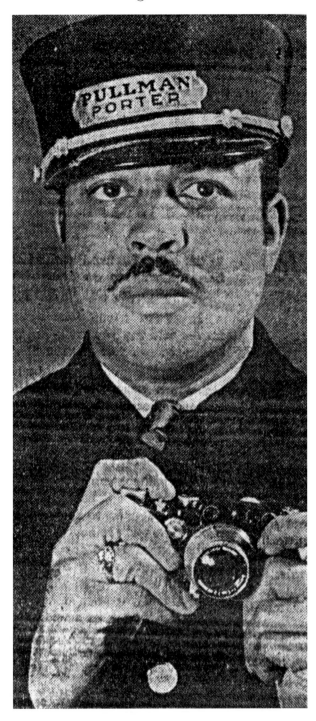

Moses Preston.

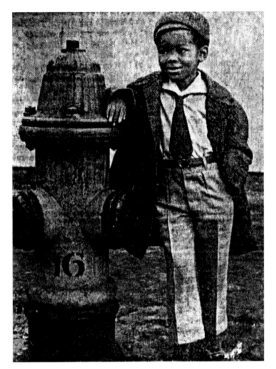

Preston's "So Big" photograph.

of images he had taken depicting scenes from Florida to Idaho as he traveled across the United States. Preston became known for having a remarkable knack for catching the beautiful in the commonplace and even for what might be considered ugly subject matter. Preston's apartment at 544 South Nineteenth Street had been converted into a negative-cluttered studio in which the kitchen served as a darkroom. He took over seven thousand images.

In his zeal to photograph waterfront scenes, he was arrested in Miami in 1940. Police were jittery over German vessels coming into Florida harbors and thought that he might have been a part of the situation. Things became especially thorny when they confiscated his notebook, in which he kept a record of all of his negatives. All is well that ends well, however. Once the G-men realized that his motives were on the up and up, he was released. He commented at the time, "Funny thing about the whole incident is that the pictures I had taken could be found on thousands of three-for-a-nickel postal cards sold around Miami."

The article consists of many excellent Preston photographs. One really stands out. It is entitled "So Big," showing his son standing in coat and tie next to a fire hydrant.

Defining Personalities

PRINCE WELLS, BICYCLE CHAMPION AND ENTREPRENEUR

In downtown Louisville, at 540 South Fourth or 737 South Third Street, just look up and you will see the namesake of Prince Wells.

Wells was a pivotal figure in bicycling and the infancy of the automobile trade, two technologies that he had the good fortune to bridge during his lifetime. He was born William Prince Wells in 1866 in Bloomfield, Kentucky.

Sometime between 1883 and 1887, Wells became a professional bicycle rider and traveled around the nation on his "ordinary" or "penny farthing" bicycle. Along with his wife, Rosina, Prince Wells also appeared for a time in vaudeville.

In addition to bicycle racing, his ability to do "trick" riding was summed up quite well by the Mitchell, South Dakota *Republican* on September 29, 1887, when he was racing and performing there:

> *Prince Wells, the invincible champion trick cyclist of America, will give a grand bicycle, unicycle and wagon wheel performance in front of the grand stand at 11 a.m. Mr. Wells is said by the American press to be pre-eminently the finest and most skilled athlete in his peculiar line in the United States...Mr. Wells' most noted tricks are mounting the bicycle placed on chests, tables, etc. riding on an ordinary buggy wheel and standing still on one wheel on a table, riding down stairs, etc. He will then ride one-half mile on the unicycle on one wheel. He is the only ten mile unicycle record holder and his performance alone puts him at the head of his profession.*

Wells settled in Louisville in 1890 and opened a small bicycle store on Third near Walnut. His business flourished, which enabled him to purchase a twenty-two-foot-wide lot on Fourth Street near Guthrie, where he built the first building bearing his name. According to *Collecting and Restoring Antique Bicycles*, written by G. Donald Adams, Prince Wells sold American Rover (1896) and Falls City (1896) brand bicycles. He was also a dealer for Rambler bikes and other sporting-related products. In the basement of an adjacent store he had a training school for bicycle riders.

When the automobile came on the scene around 1900, Prince Wells envisioned a market for such a product, and he became determined, in spite of a skeptical public, to become part of this new technology. He became Louisville's first automobile dealer, constructing a building at 718 South Fourth Street to sell the Rambler and Jeffrey automobiles. With his great success, he was able to

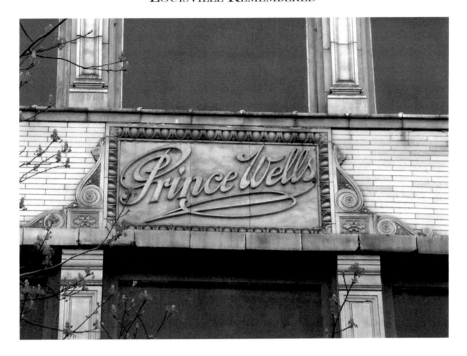

Prince Wells's first building, South Fourth Street.

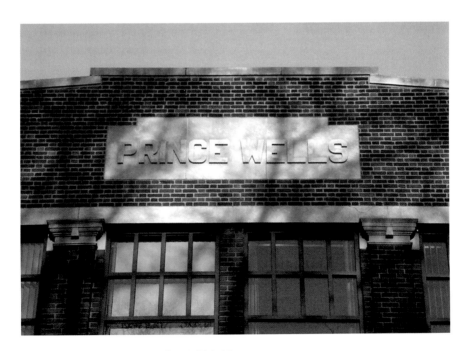

Prince Wells's second building, South Third Street.

Defining Personalities

Prince Wells was labeled the "invincible champion trick cyclist in America" in 1887.

purchase the land on which he built the second building displaying his name, at 737 South Third Street. At this location he sold the same automobiles that later became part of the Nash Motor Company. Mr. Wells stayed with the Nash automobile until his retirement in 1936.

Wells was able to prove the quality of his Rambler automobiles to at least one customer, who challenged him to make the steep hill on Peterson Avenue in Crescent Hill. Wells showed him that he could even back the car up this hill—with the car having more power in reverse. He made a believer out of the customer and sold a car in the process!

Wells became one of the founders of the Louisville Automobile Dealers Association (1903) and was its president. He was a councilman during the tenure of Mayor Robert W. Bingham in 1907 and held many other posts during his career. Wells died in 1938 at his Louisville home on Third Street following an attack of indigestion. He is buried at Cave Hill Cemetery. Prince Wells had one daughter, Princess Wells.

SUSAN LOOK AVERY—FOUNDER OF THE WOMAN'S CLUB OF LOUISVILLE

In March 1890, thirty-nine women came to the home of Mrs. B.F. Avery (Susan Look Avery) at Fourth Avenue and Broadway to discuss what was considered a "broad and elastic plan" to start a woman's club in Louisville. Their goal was to improve life in the city.

Susan Look Avery, the organizer of that meeting, was born in Conway, Massachusetts, on October 27, 1817. She graduated from the Utica Female Seminary, where she remained to teach. In 1844, she met and married Benjamin F. Avery. They traveled to Virginia, where Mr. Avery, an inventor, was perfecting his cast steel plow, a product that would revolutionize agriculture. They determined that Louisville would be the best point from which to manufacture and distribute this new product, so they set out to make it their permanent home.

After having raised six children, Mrs. Avery embarked upon a new career dealing with issues that she considered vital. One issue that was important to her was women's suffrage. Louisville's first meeting dealing with the issue was held in her parlor. Throughout her tenure with the Woman's Club, she saw many of these important struggles resolved. Among the important matters that the club engaged in were placing matrons in the county jail; giving women equal rights in property and in the custody of children; passing the anti-expectoration (spitting) ordinance; opposition to improper advertising and bill posters; and helping to create traveling libraries throughout the state. Under her watch, ordinances were passed against toy pistols and efforts were made to maintain a safe and sane Fourth of July. When asked to name what she considered the three paramount questions of the day, she replied, "At this moment that would be the single tax [dealing with a fee imposed on the economic rent of land], woman suffrage and free trade the world over."

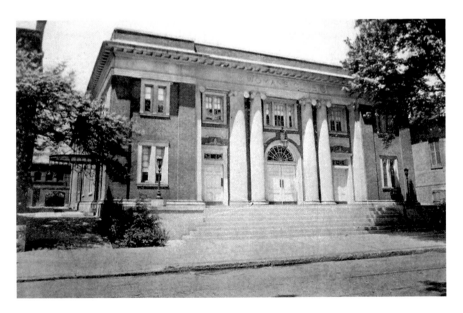

The Woman's Club of Louisville.

One of her favorite quotes was "It is bad for the ignorant and the vicious to do ill, but it is worse for the educated and the honest to do nothing."

Avery lived a long life, passing away on February 1, 1915. She did not live to see the Woman's Club building that was erected at 1320 South Fourth Street. The building, completed in 1923, continues to house meeting rooms, administration and an excellent auditorium that has been utilized for music events for many years.

The nearly eight hundred members of the Woman's Club of Louisville today can be proud of the many accomplishments that Susan Look Avery brought to their organization. They continue to be involved in the vital issues of the day. The mission of support for the Louisville Deaf-Oral School is one of those issues. This particular activity would have pleased Mrs. Avery, who suffered from a hearing impairment.

GEORGE W. CUSCADEN, THE ICE CREAM KING

If you delight in ice cream, brick ice cream in particular, you should feel even more refreshed knowing that there is a prominent Louisville connection!

George W. Cuscaden Sr. came to Louisville from Cincinnati in 1866. He and his mother opened a small confectionery shop on Market Street between

George Cuscaden, the Ice Cream King.

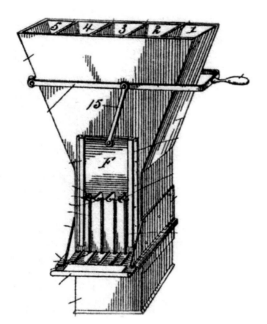

Cuscaden's ice cream brick–making machine was considered quite unconventional when he unveiled it at the turn of the century.

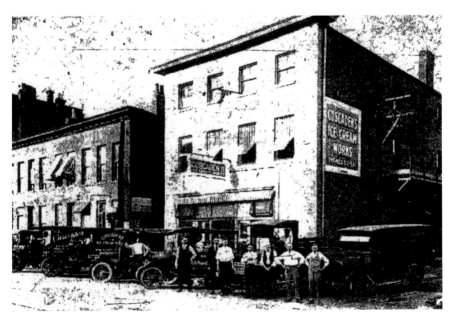

The Cuscaden Factory.

Eighth and Ninth Streets, where George made ice cream. It was an arduous process that was done by hand, but he had a passion for making the product. He constantly found ways to improve both the ice cream and the machinery that was used.

In 1875, George opened one of the first ice cream factories in the United States. It was called an ice cream depot. He was the first person to ship ice cream on railroads and one of the first to sell ice cream soda water.

Although the first ice cream machines began to appear around 1880, George conceived of a machine that would produce ice cream bricks in four colors and flavors. This device consisted of a maze of partitions, sliding vertical plates, filling receptacles and cut-off gates. It had the appearance of one of Houdini's escape devices. In 1901, he received a patent on his design and it became a major part of the Cuscaden manufacturing process. Many improvements were made over the years, but machines producing this brick-shaped product up to the present day are based on the fundamentals set forth by Cuscaden and the process employed by the Cuscaden Company of Louisville.

The Cuscaden Ice Cream Works were located in several parts of Louisville, with the main factory located at Tenth and Jefferson (in 1880). The tornado (cyclone) of 1890 destroyed the entire plant. The resilient Mr. Cuscaden then completely rebuilt the operation at 619 South Second Street and remained there for twenty-three years. He had various parlors in the downtown area, including one on Fourth Avenue, between Green (Liberty) and Walnut (Muhammad Ali Boulevard). He had a combined bakery, confectionery and ice cream establishment at Fifth and Chestnut.

In 1931, Cuscaden Ice Cream Works was merged with the Furnas Ice Cream Company.

George Cuscaden died March 11, 1924, and is buried at Cave Hill Cemetery.

END OF AN ERA—BOB RYAN, THE "SMILING IRISHMAN"

Bob Ryan Auto Sales was truly a Louisville landmark. Louisville's number one used car lot, as it was called, was a fixture at the northwest corner of Seventh and York Streets (740 South Seventh Street) for fifty-three years. Bob Ryan was also well known as a country music disc jockey and a popular Louisville celebrity. As the signs were dismantled and trucked away, another landmark vanished from our city.

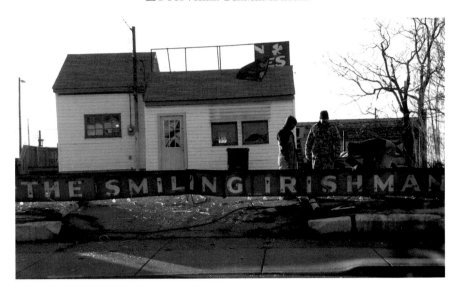

The remnants of Bob Ryan's auto sales business in 2008.

RUDOLPH F. VOGT AND HIS TOBACCO COMPANY

Let's quickly rewind to 1902, a time when tobacco was very popular. Cigars, pipes, cigarettes and all means of ingesting nicotine created a huge industry that continues to resonate.

With the frenzy over the smoking bans of today, specialty "tobacco" stores have been shifted to the back burner, although some of these have been able to survive and even thrive. With today's methods of sales glitz and marketing schemes, one has to respect the merchandising expertise of Rudolph Vogt.

Mr. Vogt opened a store at 236 Fourth Street in Louisville and named it (appropriately enough) the R.F. Vogt Tobacco Company. This was a department store dedicated to tobacco and all of the merchandise that surrounded it. It was said at the time that Louisville, without a doubt, had the best-equipped cigar store in the United States. The business occupied a four-story building that might remind one of a high-end jewelry establishment of today, with its glass showcases and specialty areas. The retail showroom was furnished throughout in solid mahogany and plate glass, with a ceiling of colonial design displaying mahogany beams. Three hundred electric lights, together with the beautiful mosaic floor, created something of a smokers' palace. The store featured a plate-glass humidor that was airtight, with zinc shelves, a marble base and flooring of absorbent brick that was sprinkled with water to create the perfect temperature and humidity in which to protect the cigars. On the other side of the wall were airtight cases that were

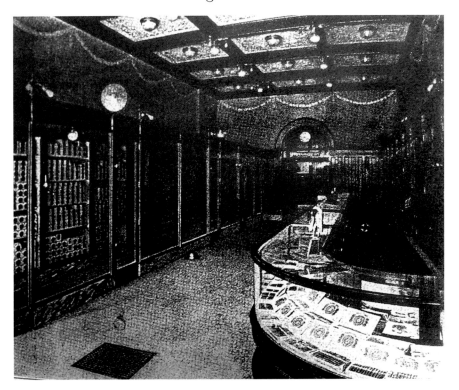

The interior of Vogt's store.

stocked with an assortment of cigars, cigarettes, stogies, pipes and smoking and chewing tobaccos. The second floor was equipped with a humidor for Seed and Havana five-cent cigars, with an inventory of some two million cigars in all.

The Vogt Tobacco Company was large enough to employ eight travelling salesmen in Kentucky, Indiana and Tennessee.

PART II

Industrial Achievement

Louisville's Industrial Legacy

When I drive through areas outlining the downtown of our city, I am impressed by the fascinating diversity of manufacturing that was once located here. These huge factories arose from the spirit of our local citizens. None of these companies was far from where its employees or management lived, in an area bounded roughly between Fifth Street, around Thirtieth east and west, Broadway and Algonquin Parkway north and south. South of downtown, and east to the Bardstown "Pike," industries dotted the landscape as well. Our corporate past was built during and after the Industrial Revolution with innovation and a notion that the companies would last for generations. These great facilities were not a "division" of some other company located in some distant city or even country. They grew out of the ingenuity of our own citizenry.

It is hard to believe that within a generation following World War II virtually all of this great manufacturing had vanished from this city, testimony of the new "global" world that we live in. The many buildings that they occupied stand as historic reminders of these great companies. On the website www.oldlouisville.com, much of this area within the city would be referred to as "Louisville after the bombings?" a sad reminder of how quickly things can change.

Of the many buildings and physical surroundings that were erected to house all of this industry, some, such as the Louisville Textile Mill on Goss Avenue, have been successfully adapted to reuse, in this case for an antique mall and restaurant. The Frank Menne Chocolate Company on east Main is now Plumbers Supply Company.

On Seventh Street near Hill is the decaying centerpiece of the American Standard Company, a complex of some sixty buildings covering over fifty acres. It was said during the 1950s that two out of three plumbing fixtures in homes in the United States were built in this plant in Louisville, Kentucky. Theodore Ahrens parlayed ten separate businesses into one Standard Sanitary Company, which ultimately became American Standard. This great building and its environs sit dormant today. Even Ahrens's dream of making vocational training available to any person who wanted it is no longer a reality. His trade school covering a square block of downtown Louisville has also become a part of that "adapative reuse" that we hear so much about.

Two other phenomenal enterprises in Louisville also come to mind. One was the Mengel Box Company. It stood just west of downtown, with the company name proudly etched in concrete up toward the top. Mengel defined the art of woodworking, first with whiskey barrels and wooden boxes and then with furniture and household goods of all kinds. Mengel was a major player in the Curtiss-Wright experimental wooden airplane project that was located on the campus of our international airport and was a precursor to the airport itself. At one time, Mengel even owned a fleet of steamships to supplement its importing and exporting business.

Just up the street from Mengel was (and still is) the Vogt company, with what was probably the largest industrial complex ever to be located in Louisville. Henry Vogt started a machine shop around 1890 that ultimately resulted in the manufacture of gate valves, plumbing fittings, flanges and giant boilers. Vogt today is known as an important manufacturer of ice-making equipment and supplies, even though many facets of the company have been divested.

Most of these companies were self-contained; the idea of "outsourcing" or using vendors was not a part of their strategy. These companies reflected the independence and fervor of their owners—the idea of "going it alone." These factories had their own foundries and metal-stamping plants. They would fabricate virtually all of the interior components in a product, thereby having full control of the manner and means of production. By today's standards, this would not be considered a prudent way to manufacture.

Of course many factors came into play that brought about the demise of local industry, including labor issues, automation and obsolescence of the very products that were manufactured. Whatever the reasons for all of this, what little remains of these great plants conjure up thoughts of Fritz Lang's film *Metropolis* and the giant machines that were necessary to keep a city viable. Most likely we will not see manufacturing activity on such a grand scale again. There *is*, however, a viable marketplace based around small

business—the so-called mom and pop operations that are such an important element in the commerce of our city of Louisville. It is these businesses that we should cherish and try to protect. They are what help to define Louisville as a special place, unique and distinctive.

SEAGRAM'S DISTILLERY AND MANSION

The opening text is furnished by Steve Clark of Dismas Charities (dismascharities.com) concerning the Seagram's mansion.

In 1936, Joseph and Joseph, Inc., a prominent local architectural firm, began construction of the Calvert and Seagram's distilleries in Louisville's west end. Reflecting the Art Deco styling which became so popular in the 1930s, these brick, stone-trimmed buildings provide mirror images of one another. Each originally had a 5,000 bushel capacity, and during World War II, Seagram's converted these facilities for the production of industrial alcohol. Used in the manufacture of smokeless powder, synthetic rubber and various medicines, this substance played a vital role in the American war effort.

The administrative office building of the Seagram's enterprise stands near the plant's production facilities. This fine two-story structure, with its massive Tuscan-Doric portico and elaborate entry enframement, introduces

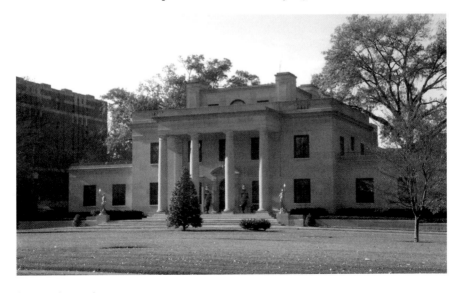

Seagram's mansion.

*a taste of English Regency Revival to the industrial complex. Marble floors
and walnut paneling enhance the interior of the building.*

The administrative building is connected by tunnels to the many brick
warehouses that surround it, allowing barrels to be moved from building
to building without being visible. Seagram's distillery ended its operation
in Louisville in 1980. For a number of years, the buildings fell into despair.
Enter Dismas Charities.

Dismas Charities is one of the nation's largest not-for-profit providers,
specializing in community-based reentry programs. It was founded in
Louisville by Father William Diersen, a Roman Catholic priest and prison
chaplain, with the help of five Louisville councils of the Knights of
Columbus. Dismas Charities was looking for a home for its headquarters
and the Seagram's headquarters mansion fit the bill beautifully.

Dismas Charities is to be commended for its efforts after taking possession
of the building in 1998. It was in a perilous condition at the time. Dismas
carefully returned this building to its original glamour and place of elegance.
To achieve this, it spent some $1.4 million on restoration.

Dismas Charities has made a commitment to the integrity of this
magnificent building. It is one wholly in keeping with the Louisville Historical
League's dedication to preservation and appreciation of our cultural heritage.
In its own words:

> *It is our hope that the spirit and honor of those who vested their lives at this
> establishment, prior to the Dismas ownership, will pass, as energy must, to the
> Dismas family, and that as Dismas moves forth in its mission of* Healing
> the Human Spirit, *it will incorporate the integrity, craftsmanship and
> tradition forever ensconced in the Seagram's crest above our door.*

BENJAMIN FRANKLIN AVERY—THE AVERY PLOW AND TRACTOR

Benjamin Franklin Avery created an industrial empire in Louisville that
ultimately included farm implements, banking and insurance. His presence
was felt for some 110 years in this city, and in many ways he was instrumental
in giving Louisville an identity with farming and agriculture. The name
"Avery" became known around the world.

Avery was born in 1801 in Aurora, New York. He grew up and worked
on a large family farm and became a well-educated man, graduating from

law school in 1822 and becoming a member of the bar in New York City. He developed a dislike for the legal profession and felt that he wanted to combine his interests in things mechanical and his love for farming. He believed that he had a better idea to replace the conventional plow and started manufacturing his newly designed Avery plow in 1825 at a blacksmith shop in Clarksville, Virginia. He had $400 of start-up capital.

Avery employed his young nephew, Daniel Humphrey Avery, to help him find an ideal location to expand his plow business. Daniel found that Louisville was a strategic location and a good distribution point, so he moved here first, working at the Jabez Baldwin foundry on Main Street (which became the plow factory of Brinley, Miles and Hardy). At his urging, Benjamin moved the Avery Plow factory to Louisville in 1847, locating the business at Preston and Main Streets. He soon built a large factory at the corner of Fifteenth and Main and also began publishing a bimonthly magazine entitled *Home and Farm* that greatly enhanced the company's connection to agriculture. The business flourished in Louisville through wars, panics, financial difficulties and even floods, but it ultimately could not survive the upheavals of technological innovation, a changing world market, buyouts and mergers.

In 1863, Avery brought his sons, Samuel and George, and his son-in-law, John C. Coonly, into the business. The operation expanded greatly in the years following the Civil War. It continued in the farm implement business, and by 1875, it had become the world's largest producer of plows, shipping about 190,000 units per year. It also manufactured tillage implements, including harrows, planters, cultivators and practically all the hardware needed for tilling the soil and harvesting crops.

Benjamin Avery died in Louisville on March 3, 1885, but the company remained under family control. By the early 1900s, it became apparent that the company needed to expand. Land was purchased on Seventh Street at Mix Avenue (1721 South Seventh Street), and work began on a new plant.

The new plant opened in 1910 and was strategically organized for the expansion of Avery into the tractor market. In 1915, a new tractor, known as the Louisville Motor Plow, was introduced. The company claimed that it could plow six acres of land in a ten-hour day! The new plant expanded rapidly, ultimately occupying fifty-eight acres of land and some eighteen buildings. From its inception through the mid-1950s, the Avery plant on Seventh Street employed between six hundred and one thousand skilled workers. Today, Avery brand farm tractors and their variants are prized possessions with collectors around the world.

George C. Avery, the last surviving son, died in 1911, and for the first time the Avery Company was out of the hands of family control. Following the

The Avery complex as it looks today.

Depression, Avery developed a design for its implements under the name of Tru-Draft. By 1939, a new tractor was designed to take advantage of the Tru-Draft system, and Avery made arrangements with the Cleveland Tractor Company (Cletrac) to begin building it for the company. The first model to be released was named the General Model GG. It sold for $595 at the time. By 1942, the B.F. Avery Company had purchased the equipment, inventory and all rights from Cletrac, though Cleveland Tractor continued to build the product. Avery continued to expand into the tractor market, but many other companies were now competing against them. After World War II, the company continued to introduce new models to satisfy an ever expanding market, but the Korean conflict and a declining farm economy hurt Avery in the early 1950s. To add to its problems, worker unrest resulted in the organizing of the Avery workers by the United Auto Workers (UAW) in 1953, and a number of strikes and labor issues followed.

In 1951, Avery merged its entire operation with the Minneapolis-Moline Company, a large manufacturer of farm implements. To save money, the classic Model A tractor was dropped from production. With Avery producing products under the M-M name, it continued to incur heavy losses. By the mid-1950s, what remained of the manufacturing operation was moved to other M-M plants. Tractors under the name of B.F. Avery disappeared from the landscape by the mid-1950s. The farm implement business from that point changed rapidly, with even Minneapolis-Moline being absorbed into White Motor Company in 1969, White into Allied Products in 1988 and Allied into AGCO (Allis-Gleaner Corporation). AGCO today owns titles to many of the former independent manufacturers, including Massey-Ferguson, Case International and, in a sense, even B.F. Avery.

Industrial Achievement

Many of the buildings that were part of the Avery complex on Seventh Street exist today. Part of the complex is occupied by a large industrial laundry. Although a portion of the office complex remains, much of it has been razed and is occupied by the Peerless Electronics Company. The row of manufacturing buildings at the rear portion of the property remains, occupied by a number of small business and manufacturing concerns.

The history of the B.F. Avery Company exemplifies the growth, life cycle and decline of American manufacturing. It experienced the difficulties of survival in a single-source environment and the way that world market conditions influence the manufacturing and distribution of industrial goods.

GUSTAVE BITTNER, FURNITURE BUILDER

When Gustave Bittner opened his one-man cabinet shop at 13 East Street (now 415 Brook Street) in 1854, little did he realize that he would create a legacy of one of the few continuously operating manufacturing operations in Louisville. It was one that would serve furniture and cabinet building to the present day.

During this period, the railroad was just starting to play a role in the transportation network. Steamboats were the major resource to provide goods and services as they moved up and down the Ohio River. These huge boats with their ornamental woodwork represented a large part of the work for an artisan such as Gustave Bittner. In the 1800s, furniture and cabinets were made by hand. It was an arduous and time-consuming process. Bittner persevered and continued to build his business by word of mouth. He was eventually able to expand by hiring other craftsmen to help in his shop.

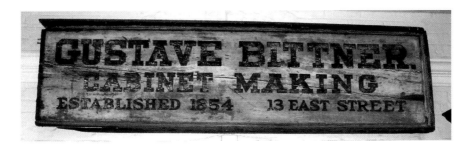

The sign for Bittner's cabinetmaking store.

When Gustave died in 1895, his son William succeeded him as president of the firm and his nephew Joseph became secretary. In 1909, the business was incorporated as G. Bittner's Sons, and the firm moved to larger quarters at 427 South First Street, where it had offices and display rooms at the front and a four-story manufacturing facility at the rear.

Today, Bittner's is located at 731 East Main Street. The facility still maintains an excellent wood shop that builds cabinets, tables and other furniture. In the furniture shop, you can still find some of the tools of yesteryear, including a planing block and a manual plank saw. Bittner's also performs various types of restoration, repair and even duplication of venerable furniture pieces. The company is no longer part of the Bittner family, but it carries the vision of Gustave Bittner forward into a third century.

Candy Manufacturing in Louisville

With no pun intended, Louisville and southern Indiana enjoy a rich history in the manufacturing and distribution of candies and confectioneries. This area is the birthplace of several specialty items. This has created interest from around the world. Since the Industrial Revolution, the livelihoods of thousands of local workers can be attributed to the candy trade.

It is hard to know exactly when and where it all started, but certainly one of the most important early contributions was when Peter Bradas started his candy plant in Louisville in 1833. It was the first candy factory to open in the region, and when it closed it was the oldest candy maker in the United States. The operation was taken over by his son, James Bradas, in 1881, and by 1899, C. Edwin Gheens had joined the firm, which was then known as Bradas & Gheens. The Bradas & Gheens operation remained viable well into the 1960s. Famous stage and movie star Victor Mature was employed there as a teenager. The building at its final location at 817 South Floyd still stands today, a city block square; it is no longer a candy plant but certainly a reminder of the Nightingale chocolates and Anchor Brand candies that were made there.

In 1882, Frank J. Menne started his chocolate manufacturing plant at Main Street and Wenzel, which employed several hundred workers. By 1898, it was shipping over seventy-five thousand pounds of chocolate a year. About 1925, the Menne Candy Company, with its famous "Eagle Brand" chocolates, was purchased by the National Candy Company, which was located at Fourteenth and Broadway. The building that Menne had erected is currently the home of Plumbers Supply Company of Louisville.

Industrial Achievement

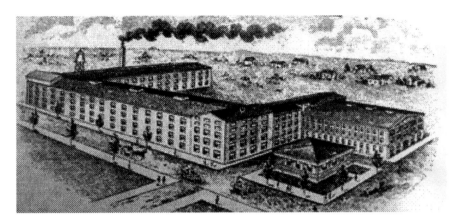

Bradas & Gheens candy plant. The confectionery industry has a rich heritage in Louisville.

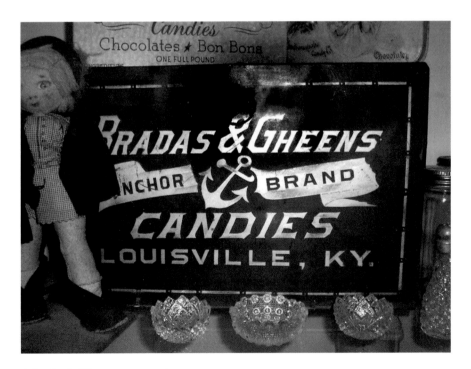

A Bradas & Gheens company sign.

Candy manufacturers both large and small have come and gone. Needless to say, as in most industries, many of the smaller companies were started by those who trained at the larger ones. This was particularly true for those who worked at Bradas & Gheens. For one thing, the art of chocolate dipping was a tightly

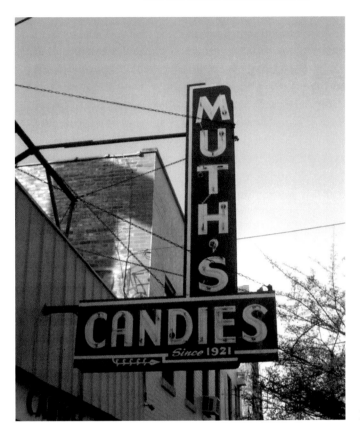

Muth's Candies.

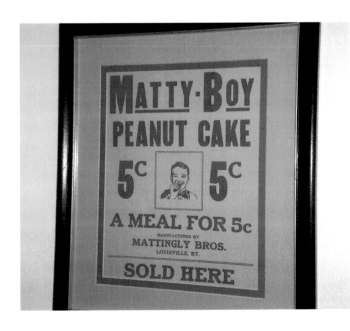

A sign announcing Matty Boy Peanut Candies.

held secret; chocolate dippers did this to maintain job security. Knowing how to chocolate dip became something of a rite of passage for those in the trade. Recipes were also closely guarded secrets. From the Louisville and southern Indiana markets came bourbon candies, the famed Modjeska caramel, the Jenny Lind cough drops, the Chocolate Pickaninny and the Matty Boy Peanut Candy. Solger's marrons glacés and chocolate truffles were popular long before the Brown Hotel was built on the same site.

The candy and confectionery industry has been beset by problems brought about by several tragic fires, a string of labor disputes and other difficulties. Before air conditioning, candy manufacturing was very arduous during the summer months. This was exacerbated by long hours, low pay, few benefits and generally a high degree of labor with a very small margin of profit. The sugar rationing from two world wars made matters worse.

It might be said, however, that candy making has been a resilient trade with a remarkable past and hopefully a bright future.

The Polish-born actress Madame Modjeska (born Helena Opid) was performing at Macauley's Theatre in *A Doll's House* in 1883. Anton Busath, owner of the candy store under his name, was so impressed with her that he named a caramel candy in her honor. The caramel treat became very popular in the Louisville area, and when the Busath store closed its doors following a fire in 1947, the use of the Modjeska name and this candy remained popular. To this day it is a celebrated staple made by the Schimpff Confectionery in Jeffersonville, Muth Candy on Market Street, Bauer's Candies of Lawrenceburg, Kentucky, and others. The famed portrait of Madame Modjeska that hung in the Busath Fourth Street store is now in the possession of the Filson Historical Society.

Several candy stores that manufacture their own products have stood the test of time. Schimpff's Confectionery was started on Preston Street in Louisville in the 1850s. Gustav Schimpff Sr. started the store in the present location in 1891 on Spring Street in Jeffersonville. Today the Schimpff Confectionery is run by Warren and Jill Schimpff. Warren is the great-grandson of Gustav Schimpff Sr. In addition to selling candy, Schimpff maintains an on-site museum dedicated to the candy industry.

Muth's Candy Store at 630 East Market was started in 1921 by Rudy Muth after he returned from World War I. Along with his future wife, Isabell Stengel, other family members and friends, Rudy became successful with his handmade chocolates, Modjeskas and bourbon chocolates. Muth's still celebrates a tradition started by Rudy Muth.

Bauer's Candy was started in 1899 here in Louisville. It enjoyed a long tenure in the city, having as many as three locations. Now in its

fourth generation, Anna Bauer Satterwhite operates Bauer's Candy in Lawrenceburg, Kentucky. It still makes most of its own candy, including the Modjeskas that are its specialty.

Candy making today survives in this locality because of these smaller businesses. Gone are the candy "factories." Most of the major players in the realm of candy manufacturing today operate out of large, highly automated factories and are few in number. It is unlikely that a Bradas & Gheens or a Frank J. Menne Company will prevail in the Louisville landscape of the future, but it is important to know that these companies helped to form the fabric of our local history.

MUSICAL INSTRUMENT MAKERS

Louisville has a long history of musical instrument manufacturing.

The famous Adler piano and reed organ company, Pilcher Organ Company, Louisville Pipe Organ Company, Steiner, Miller and other pipe organ builders have made their marks in Louisville history. Cliff Blackburn and his now famous "Louisville Lead Pipe" for trumpet had its origin in Louisville. He now manufactures a complete trumpet in his factory near Nashville, Tennessee.

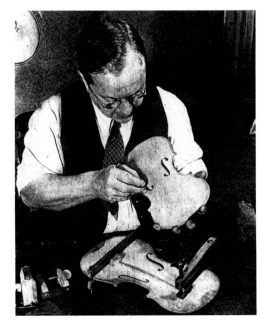

H.J. Schulz carefully cuts "F" holes into a violin top.

There have been numerous local guitar and string instrument manufacturers. William Doolittle, Lee Fox and Fred Couch built and repaired string instruments throughout the last half century.

There are excellent products being built today by the Sullivan family of First Quality Music, located in Louisville's Riverport center, and Louisville string and guitar luthier Jim Steilberg, of Steilberg String Instruments, is highly respected.

Highlighted in this column is one artisan who made his mark in Louisville some sixty years ago. H.J. Schulz had a violin manufacturing facility in Louisville at 1573 Bardstown Road in the 1930s and early '40s. He approached instrument building from a slightly different perspective than traditional string manufacturers. An electrical engineer by trade, he was a man of many interests, including photography. He found that the old violin makers in Italy were able to match their woods more effectively than later makers. He was able to devise a photoelectric device that helped visualize the uniformity of the wood to approximate those used in the great violins.

Mr. Schulz used maple in his violins, searching for the older, more seasoned woods. He was even able to obtain slabs of maple from New England that dated to the fourteenth and fifteenth centuries. He carefully experimented with different thicknesses and glue strips to achieve the best sound. Mr. Schulz could spend as long as a year building a fiddle. What became of the Schulz violins is anybody's guess. It would be fascinating to locate one of these "Louisville violins."

Louisville citizens can be proud of these musical craftsmen.

KENTUCKY WAGON MANUFACTURING COMPANY

A recent announcement was made both by the University of Louisville and the *Louisville Courier-Journal* that the university had purchased the thirty-two acres currently occupied by the Kentucky Trailer Company, located on Third Street just south of the University of Louisville Belknap campus. This facility was formerly occupied by the Kentucky Wagon Manufacturing Company. Kentucky Trailer is moving its manufacturing concern to the Riverport Industrial complex in southwest Louisville.

This leaves many of us in historic preservation wondering what will become of the facility that Kentucky Trailer is leaving behind and thinking about the more difficult question of the historical significance of the property. As with other recent concerns of the Louisville Historical League, it will mean trying

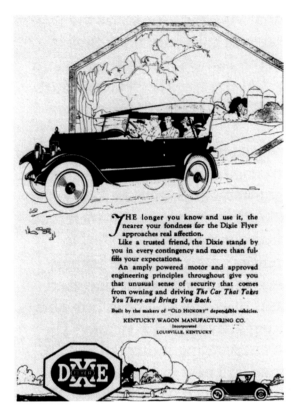

THE longer you know and use it, the nearer your fondness for the Dixie Flyer approaches real affection.
Like a trusted friend, the Dixie stands by you in every contingency and more than fulfills your expectations.
An amply powered motor and approved engineering principles throughout give you that unusual sense of security that comes from owning and driving *The Car That Takes You There and Brings You Back.*

Built by the makers of "OLD HICKORY" dependable vehicles.

KENTUCKY WAGON MANUFACTURING CO.
Incorporated
LOUISVILLE, KENTUCKY

The Kentucky Wagon Manufacturing Company's Dixie Flyer was "the car that takes you there and brings you back."

to open a dialogue with the new owners in an effort to persuade them to reuse and readapt whenever possible.

The Kentucky Wagon Manufacturing Company had a complicated and tumultuous history since its founding in 1878. The company moved from its original location on East Walnut Street (Muhammad Ali Boulevard) to the new facility on South Third Street in 1889. The first president of the company was Stephen E. Jones. The facility had a lumberyard, shop buildings, kilns, machinery and welding facility, a forge and a complete electrical plant. Wagons of all kinds were built under the trade names of Tennessee, American and Old Hickory.

With the advent of the automobile, Kentucky Wagon began to fall on hard times. The various loans, mortgages, mergers and joint ventures are too numerous to mention. In 1914, Robert V. Board became president of the firm, and it expanded into several areas, requiring considerable expenditure of capital. To complicate matters, during World War I, the plant was turned over to the government. At the end of the war, the plant had much surplus material, which was sold at a loss. It became involved with the manufacture

Industrial Achievement

Louisville Leaders of Business and Industry in Their Offices

Robert V. Board, president of Kentucky Wagon Manufacturing (KWM) Company from 1914 to 1931.

KWM's original headquarters, Third Street.

of battery-powered trucks and from 1916 to 1924 it built the Dixie Flyer, a four-cylinder motorcar similar to Ford's Model A Roadster. In 1930, it received notoriety for motorizing the Gentry Brothers Circus with specialized truck bodies placed on General Motors chassis.

In spite of some very creative thinking, and an alliance with a larger company, the National Motors Company, things began to collapse around its operations. In January 1931, the company was deemed bankrupt and an effort was started to disburse the assets of land, buildings and machinery. Enter the Tway family.

In 1936, the remaining assets of Kentucky Wagon Manufacturing Company and the Dixie Motor Car Company were purchased by Robert C. Tway Sr. and renamed the Kentucky Manufacturing Company. Mr. Tway saw the need for a maker of top-quality trailers and vans. In the 1960s, the name Kentucky Trailer became synonymous with moving vans. Kentucky Trailer and a link to the Tway family persists to this day under President Gary Smith.

THE LOUISVILLE CONSERVATORY OF MUSIC

"Once upon a time" would be an appropriate opener for describing the Louisville Conservatory of Music, which occupied our city for only sixteen years but laid the foundation for what was to become the music school at the University of Louisville.

The website www.oldlouisville.com has a section referred to as "Louisville after the bombings?" that describes much of the precious architecture that we have lost (much of it during the blitz of the 1970s urban renewal). The text helps to illustrate the grandeur of the architectural gems that adorned Broadway between Preston and Eleventh Streets. This is a story about one of those jewels.

The Louisville Conservatory of Music was organized by Frederic A. Cowles and James Wesley McClain. Cowles was organist and choir director at Calvary Episcopal Church, and McClain was well known locally as a vocal instructor. The school opened on September 7, 1915, at 214 West Broadway in the 1877 Victorian mansion built by businessman W.H. Dillingham. Mrs. Dillingham, an accomplished organist, had used the home for recitals over the years. A pipe organ was already installed there. The house required some remodeling to create the classrooms, two-hundred-seat recital hall and dormitory accommodations, but it worked out well for the early years of the school's development.

During the course of the next ten years or so, the school grew from the small faculty and around 200 students—teaching the essentials of sight

Industrial Achievement

Frederic Cowles.

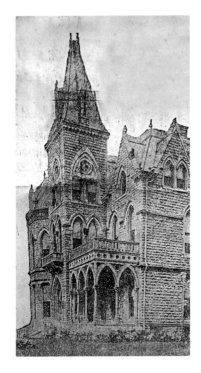

Louisville Conservatory of Music's first location was this Victorian mansion built by W.H. Dillingham, West Broadway.

reading, harmony, vocal, piano and strings—to an expanded program of instrumental instruction, orchestra (ensemble), art, public school music, drama and an enlarged children's department. In 1921, the school purchased a building at 233 East Gray Street for use as a dormitory for out-of-town girls. This building was expanded over the years, and by 1923, the school had purchased property at 239 East Gray Street, which was connected to the original unit. The new three-story dormitory unit even included a library and a two-manual pipe organ for student use. The enrollment by this time was nearly 1,800 students representing some twenty-two states.

The school continued to grow and diversify, and by early 1926, it was decided to acquire new property at 720 South Brook Street (at Jacob Street) and build a new conservatory building. The new four-story building comprised some sixty studios, ten classrooms and administrative offices. By this time, the faculty alone numbered some sixty teachers. The school continued to thrive in music, art and drama, even adding a new dramatic department head in August 1928.

The early 1930s were not kind to the conservatory. Along with the stock market crash of 1929, there was strife within the management and stockholders as to what measures to take to reduce declining attendance

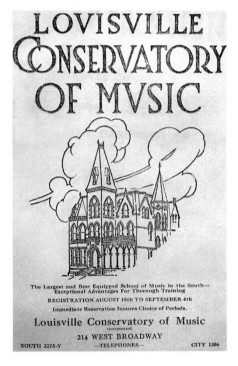

An original advertisement for the conservatory.

and increased debts. It was finally decided to file a voluntary petition of bankruptcy in U.S. district court on November 14, 1931, which brought something of a sad end to what was a proud period in Louisville history—a strong training ground in music and fine arts. Fortunately, a year later the University of Louisville would emerge with its newly formed school of music. The conservatory building became a casualty of the I-65 north–south expressway system built in Louisville in the late 1950s.

LOUISVILLE CHAIR COMPANY

The industrial history of Louisville is a fascinating one. There have been several thousand manufacturing companies in the city since its founding, many of which we will never know about. Louisville Chair Company is one industry that stands out. It was founded in 1919 by Phil Conrad and his son Milton Conrad Sr.

Louisville Chair Company began manufacturing walnut dining room furniture in a shop at 1456 South Preston, expanding into wooden chairs and other furniture. In 1926, it moved the operation to 1367 South Eleventh Street, between Magnolia and St. Louis Streets, in what was the heart of Louisville's manufacturing district at the time. It would remain there throughout the rest of its history. During World War II, a large portion of the production shifted to government work, manufacturing some 200,000 barracks chairs, table armchairs, spatulas and more. In 1948, the emphasis shifted to the production of metal dinette furniture and metal-based chairs. By 1958, sales of this company were excellent, enjoying as much as 62 percent growth in a single year.

At its peak, Louisville Chair employed some 370 workers in both the wooden and metal furniture divisions. Its "Style Setter" series of dinettes became very popular in the 1950s, being made in chrome, wrought iron, black tubular and brown tone.

Louisville Chair had several "firsts" to its credit. This business was one of the original exhibitors at Chicago's American Furniture Mart in 1925 and the first company in 1932 to show a chrome chair and table with chrome legs and wooden top. It was also the first to use corrugated containers for shipping its products. At one point, Louisville Chair had thirty-three persons in its national sales division alone.

In 1965, production and maintenance workers, clerical workers and garage mechanics voted to affiliate with Local 236 of the United Furniture Workers union.

The Louisville Chair Company building as it appears today on South Eleventh Street, in the heart of the city's old manufacturing district.

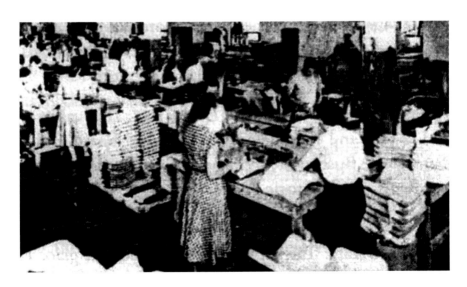

Louisville Chair Company employees at work, 1950s.

There were labor issues that persisted throughout the 1960s. The company, for whatever reason, never enjoyed the growth and notoriety that had occurred up to that time.

The last year that Louisville Chair Company was listed in the *Kentucky Directory of Manufacturers* was 1982.

WIBLE MAPOTHER, PRESIDENT OF THE L&N RAILROAD

Many pioneers helped make the city of Louisville the metropolis that it is today. Unfortunately, most of them are long forgotten, barely a footnote in the archives of this city's history. Theodore Ahrens, Henry Vogt and C.C. Mengel Jr. were all vital players in creating local industry. Wible Mapother was such a figure. In 1921, at the age of forty-nine, he became the president of the Louisville and Nashville Railroad and one of the youngest corporate heads in the nation at that time. He helped guide the railroad through one of its most important periods of growth. During his years of service, he became known as an "empire builder." Mapother was one of Louisville's most prominent citizens, being involved with the Board of Trade and the Transportation Club.

Wible Mapother was born in a residence on Third Street, between St. Catherine and Oak Streets, on September 28, 1872. During his entire life, he never lived more than two blocks away from that address. He was the son of Dillon H. and Mary Cruise Mapother. His father operated a lithographing and printing business at Third and Market Streets under the name of Hart and Mapother. At the age of sixteen, Wible decided upon a career as a railroad worker. He applied for a position of office clerk at the L&N Railroad, embarking upon a thirty-eight-year career that included many twists and turns. He quickly convinced his superiors that he was no ordinary "office boy," as one was referred to at the time. Wible had what one writer called "ambition, determination, effort and ability."

He rose quickly through the ranks, becoming, at thirty-two years of age, the first vice-president of the railroad. With the important function of the railroads during the First World War, Wible's administrative talents were recognized by William G. McAdoo, wartime director general of the United States Railroad Administration, who appointed him federal manager, with supervision over the operations of the L&N, Nashville, Chattanooga and St. Louis Railway; Louisville Henderson and St. Louis Railway; Birmingham and Northwestern Railway; Atlanta and West Point Railroad; and Western Railway of Alabama. After the war, in March 1920, Mapother was elected executive vice-president of the L&N, and one year later, on March 17, he was elected president of the

Wible Mapother, president of L&N Railroad.

railroad, succeeding Milton H. Smith. He had direct supervision over fifty-five thousand employees. Mapother was appreciated for his hands-on style and his dedication to open dialogue with his employees. He lived an austere life and cared little for the luxury in which many executives indulged.

Wible Mapother died while still in office. He was vacationing with his wife Amelia in Panama City when he suffered a heart attack on February 4, 1926. His home was located at 1429 South Third Street, a residence that appears virtually the same today. He is buried in Cave Hill Cemetery.

THE GIRDLERS—CAPTAINS OF INDUSTRY

The Girdler family left an indelible mark on Louisville and the nation. Three family members achieved national prominence during their lives. Each of these men has a story worth telling.

Walter Girdler

Walter Girdler created an industrial dynasty without ever leaving the city of Louisville. He established a corporation that was so diverse that it would take volumes to fully describe it. World War II and the climate that precipitated

Industrial Achievement

it helped to define many of Girdler's industrial achievements. His legacy is described best by the vision set out in a book published in the early years of the company, entitled *The Girdler Corporation* (printed by Manz Corporation), which states, "A record of continuous engineering and manufacturing achievement…based on ability to originate and to improve products and methods for industry."

Girdler was born in Louisville in 1887 and graduated from duPont Manual High School in 1904. After graduation, he moved to Somerset, Kentucky, to operate a general store for a time, but he returned to Louisville in 1913 to purchase an interest in the Kentucky Oxygen-Hydrogen Company. From this beginning, he expanded his company with a technique to extract helium from natural gas. Girdler created a new enterprise that he called the Helium Company of Louisville utilizing this technique, which he ultimately sold in 1938 to the federal government. This process brought him international acclaim and recognition at a time when helium was extremely important. The tragic explosion of the *Hindenburg* at the Lakehurst Naval Air Station near Manchester, New Jersey, in 1937 marked the end of the use of hydrogen for airships, and the time was right

Walter Girdler.

for this helium extraction method. The military became interested in Girdler's technique for harnessing the safer helium for lighter-than-air craft.

In all, Girdler created four divisions of the Girdler Company, within which myriad products were developed.

The Votator division manufactured a machine called a Votator. This equipment revolutionized how certain food products, especially margarine and shortening, were made. The Votator transferred heat (or cooling) within a closed container, allowing simultaneous aerating, mixing or emulsifying.

Tube Turns was a Girdler division that utilized a special pipe-bending technique that had been invented in Germany. It was a stronger method of creating bends in piping that allowed not only greater strength and safety but also less pressure loss and minimum flow resistance. The Tube Turns division was also important during the Second World War for making shell forgings, airplane and tank cylinders and aluminum cylinder heads for aircraft engines.

The Gas Processes division was highlighted by the Girbotol purification method, which is an essential part of the petroleum, natural gas and chemical industry. The Girdler Hydrogen Purification Process removes carbon monoxide and organic sulfur compounds from raw hydrogen and other gas mixtures.

The Thermex division was dedicated to the design and manufacturing of high-frequency, electrostatic heating equipment.

Girdler products and processes live on today in manufactured goods around the world. Many originate from the same plants that were built by Girdler.

Walter Girdler died in 1945 at the age of fifty-eight and is buried in Louisville at Cave Hill Cemetery.

Thomas Girdler

Thomas Girdler was born near Sellersburg, Indiana, in 1877. He was a distant cousin to Walter Girdler. Thomas graduated from duPont Manual High School in Louisville in 1896 and from Lehigh University in Bethlehem, Pennsylvania, in 1901 with a degree in mechanical engineering. Thomas Girdler became famous as a corporate executive at the highest levels and as an innovator in steel development, especially stainless steel and other alloys.

He worked for several large steel mills and manufacturers before becoming CEO of Republic Steel, near Chicago. It was the nation's third largest steel company in 1930. Girdler hired scientists and improved the quality of steels. At Republic, he became entrenched in the labor battles of the 1930s

Industrial Achievement

Thomas Girdler.

between the union, represented by John L. Lewis, and the steel giant. It was a tumultuous time for the steel industry.

With the outbreak of World War II, Girdler became the chairman of Consolidated and Vultee Aircraft, which he merged into one corporation. He introduced improved mass assembly line techniques to Consolidated and the aviation industry generally. It was under his watch that much of the B-24 Liberator bomber production took place, which played an essential role in the nighttime raids over Germany by the Eighth Air Force. A Consolidated modification center for these aircraft was located in Louisville, adjacent to the Curtiss-Wright Aircraft factory off Crittenden Drive.

Thomas wrote an autobiography, *Boot Straps* (with Boyden Sparks), published by Scribner in 1943. Thomas Girdler died in Easton, Maryland, in 1965 at the age of eighty-seven.

William Girdler

Filmmaker and producer/director William Girdler was the grandson of Walter Girdler the industrialist. William was born in Louisville in 1947. It was in Louisville that he produced five of his nine films with his new company Studio One Productions, which he formed with his friend and brother-in-law, J. Patrick Kelly.

William Girdler.

Most of his films were horror or action features. He utilized local talent whenever possible and produced much of the background music himself, using local musicians. His cast members were for the most part Louisville actors.

Girdler moved to Hollywood and produced four additional motion pictures. *Project: Kill* starred Leslie Nielson in a serious role. *Grizzly*, released in 1976, was Girdler's most successful film, earning an impressive $39 million worldwide. *Manitou* (1978) was his last film and starred Tony Curtis and Susan Strasberg.

Girdler lived his life with a premonition that he would die by the age of thirty. He achieved an incredible body of work in the few short years that he operated Studio One Productions. In January 1978, at that age of thirty, he died in a tragic helicopter crash while scouting locations for his tenth film near Manila in the Philippines. Since his death, his career and films remain popular. A number of websites have been dedicated to him. William Girdler is buried at Cave Hill Cemetery.

Thanks to William Girdler Jr. of Louisville for sharing his thoughts about his father.

Theodore Ahrens

He built an industrial empire, yet the global company that claimed 2005 revenues exceeding $10 billion does not even mention his name on its website.

He financed and nurtured the creation of a huge vocational and business school that was named after him, yet very few students who ever attended that school have any knowledge of those contributions.

Such are the spoils of history.

I am speaking here of Louisville industrialist, philanthropist and benefactor Theodore Ahrens. It was through his generosity, skill and perseverance that the company known today as the American Standard Company came into being.

The groundwork for Ahrens's career began with his father, Theodore Ahrens Sr., who started his business in Louisville in 1860, one year after his son was born (September 21, 1859). His first venture was a brass foundry. In 1866, he entered into partnership with Henry Ott, who was a practical plumber. They named the company Ahrens and Ott, specializing in steam brass work and contracting plumbing and heating installations. Ahrens and

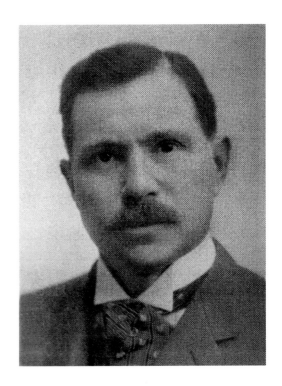

Theodore Ahrens, 1904.

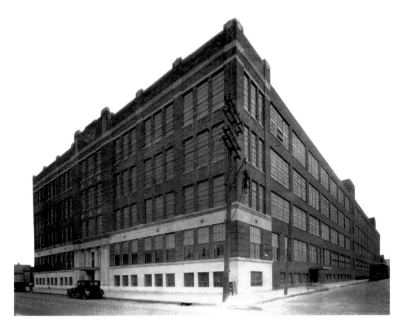

The American Standard factory. *Courtesy of the University of Louisville Photographic Archives.*

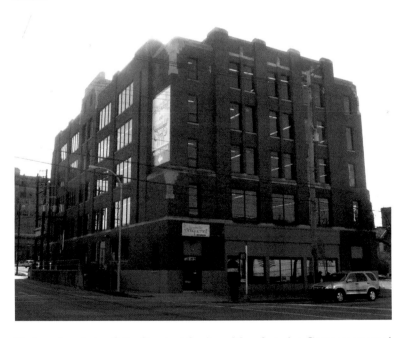

Modern-day photo of the Standard Sanitary Manufacturing Company general offices, showroom and warehouse built in 1927 on the southwest corner of Broadway and Campbell Street.

Industrial Achievement

Ott began on Market Street between Preston and Jackson, but moved in 1900 to Market Street between Fourth and Fifth and later to 327–29 West Main Street. It eventually expanded its manufacturing to include water gauges, Blakeslee jet pumps and countless other tools and devices for machinists, blacksmiths, millwrights, plumbers and steam-fitters. Theodore Ahrens Jr. joined the company in 1886, after having worked on the East Coast and then for several years operating his own plumbing business in Louisville.

In 1900, the visionary Theodore Ahrens Jr. helped spearhead Ahrens and Ott into a consolidation with ten other manufacturing companies, all involved with the plumbing or metalworking trades, to become a new company called the Standard Sanitary Manufacturing Company. By 1924, the company dominated the industrial landscape of Louisville with nearly five thousand employees, a payroll of some $6 million and an expansive facility base of over fifty buildings covering forty-two acres at its location at Seventh Street and Shipp Avenue. In 1927, it built a five-story building, which stands today, at the southwest intersection of Broadway and Campbell Street to house showrooms, general offices and warehouse space for the company.

This company had a number of "firsts." It created the largest chimes whistle in the world, which could be heard at a distance of sixty miles. The whistle was used in ship and marine applications. It was famous for "A.O." hydrants and street washers. Theodore Ahrens created a "plumbing professorship" in 1925 at the Carnegie Institute of Technology at Pittsburgh—the first time such a professorship had ever been established in any institute of learning. The gift created a specialty of instruction for plumbing, heating and ventilating. Also worthy of mention was the excellent corporate band that the company had that played countless company functions and community concerts.

In 1925, Ahrens, along with Ethel Lovell and the Louisville Board of Education, created the city's first vocational school at 546 South First Street to teach skilled trades, which included a broad spectrum of vocational education, including virtually all of the industrial trades of the day (cabinetmaking, dressmaking, bookbinding, electrical wiring, concrete construction and more). Theodore Ahrens personally donated around $1 million to build and equip the facility. In 1939, the school was officially named the Theodore Ahrens Trade High School.

In 1929, the Standard Sanitary Manufacturing Company merged with the American Radiator Company of Ware, Massachusetts, to become the American Radiator and Standard Sanitary Corporation. In 1948, the name was shortened to American Standard.

Theodore Ahrens Jr. died on June 12, 1938. He and his wife Elizabeth are buried at Cave Hill Cemetery.

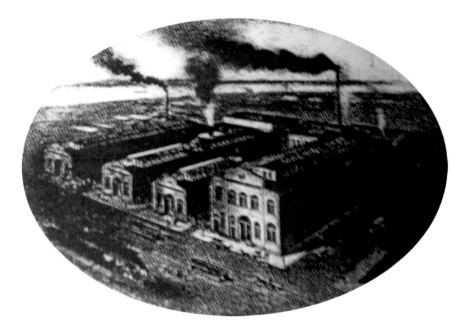

Circa 1905 photograph of the American Machine Company offices and shops, 500–530 East Main Street.

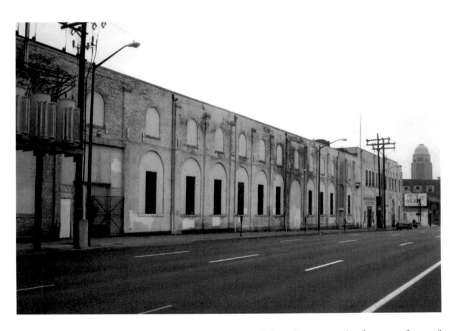

Although in need of some tender, loving care, the building shows promise for some form of adaptive reuse. The location is in the heart of the redevelopment area and just across the street from Slugger Field.

Industrial Achievement

AMERICAN MACHINE COMPANY

With the resurgence of Main Street in Louisville, dynamic changes are taking place. There are currently many exciting projects in the works. The new stadium, ballpark, condominiums and loft apartments are being built. Much of this construction is in the form of adaptive reuse of present buildings. There is some discussion of this happening to the former American Machine Company, the location most recently utilized for the Vermont-American Company. The building has been vacant for several years.

When the American Machine Company was incorporated in 1898, things were very different in Louisville; this part of Main was highly industrial.

The company's office and shops were located on 500–530 East Main Street in a two-story brick building that measured 205 by 185 feet and occupied some 80,000 square feet. It manufactured various types of machinery and at one time had one of only two Niles Boring Mills that were in use in the United States. The company made a specialty of repairing and remodeling ice plants, worked on hydraulic elevators and created specialty wood products. The president of the company was Mr. Mathias Poschinger.

CURTISS-WRIGHT AND THE SECRET "CARAVAN" CARGO PLANE

Concerns about the possible shortage of aluminum during the Second World War, coupled with Louisville's already successful wood industries —led by Mengel Box Company, Wood Mosaic, Baldwin Piano Company in Cincinnati, Universal Molded Products Corporation in Virginia and other leaders in the field—inspired the Curtiss-Wright Corporation to build a $12 million aircraft assembly plant to be located in Louisville adjacent to Standiford field just south of the city. The 570-acre tract was purchased by the city and county after the Louisville Industrial Foundation had advanced $100,000 to make it happen. It was to be accessed from Crittenden Drive.

The announcement was made from Curtiss-Wright's headquarters in Buffalo, New York, in May 1942 by no less than Mr. Wright himself. A great deal of secrecy surrounded the exact "mission" of the plant, but Louisville met all of the requirements (in addition to the wood industry). The plant was to be located safely inland and between two other major Curtiss-Wright operations, one in Buffalo and one in St. Louis, Missouri. Mr. G.J. Brandewiede would come from the St. Louis plant, where many of the sub-assemblies would be produced to head up the new Louisville operation.

The new "secret" airplane, of course, was the C-76 Caravan. Approximately 65 percent of the new airplane was subcontracted to the wood industry, with Mengel Company being the largest single entity. The wood used in the plane included hickory, spruce, gum, mahogany, birch and Douglas fir. Plywood construction ranged from three to nine plies. The Caravan was twin-engined with a wingspan of 108 feet. The first plane rolled off the assembly line less than twelve months after the plant was completed. Although some twenty of the new planes would be built, changes in war plans and an abundance of aluminum would lead to a change in mission for Louisville's aircraft plant. The need for additional C-46 Commandos for the Burma-India-China campaign toward the end of the war necessitated a change to assist the other two Curtiss-Wright plants in meeting the demand. This also represented an opportunity for local suppliers Reynolds Aluminum, Tube Turns and American Air Filter. In addition to the C-46, the plant became a modifications center for other aircraft. The navy's Curtiss SB2C Helldiver dive bombers, which were built in Columbus, received needed modifications here. Heavy bombers such as the Consolidated B-24, Boeing B-17 and B-29 also received support from the Louisville plant.

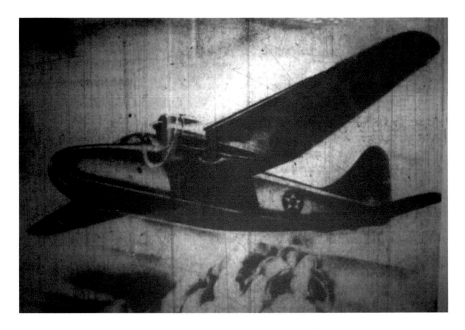

Curtiss-Wright's C-76 wooden airplane. *Courtesy of the* Courier-Journal.

Industrial Achievement

This plant would have a number of "firsts" during its short run of only three years, after which it closed in August 1945. This was one of the first attempts at building what was principally a wooden airplane on a mass-assembly basis. The plant represented a boost for the employment of women. The number of women in the workforce at this plant numbered nearly a third. An interesting footnote to the Curtiss-Wright plant was its Symphonic Choir, the first of its kind in a Louisville war plant. The chorus was made up of forty airplane builders and office workers. The director, Robert Layman, announced its debut at Nichols General Hospital in December 1944, with plans to branch out into USO centers and civic gatherings.

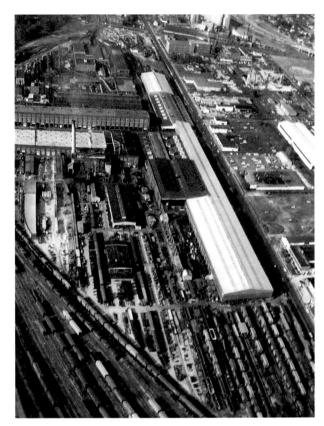

Left: 1. In 1905–7, L&N's system car and locomotive shops, sometimes called the "South Louisville" shops, were based on South Floyd Street in the area around Highland Park from 1905 until they closed in 1987. This aerial view offers an appreciation of the vast operation that provided employment for many thousands of Louisville citizens.

Below: 2. Today, Papa John's Stadium occupies the land where the L&N shops were located. University of Louisville football games are played here. *Courtesy of L&N, Louisville & Nashville Railroad,* The Old Reliable *by Charles B. Castner, Ronald Flanary and Patrick Dorin, circa 1997, TLC Publishing, Inc.*

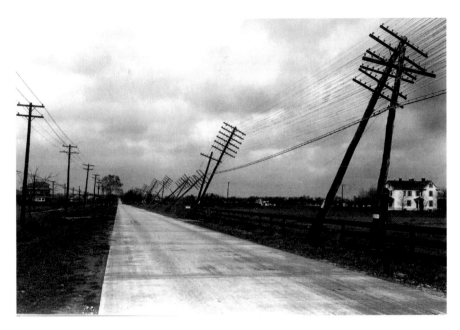

3. This circa 1920 view shows storm damage along Bardstown Road near Bashford Manor Lane, looking toward town. The farmhouse on the right still exists but can only be accessed from Goldsmith Lane. *Courtesy of the University of Louisville Photographic Archives.*

4. Much has changed in the view taken from the same perspective in 2007.

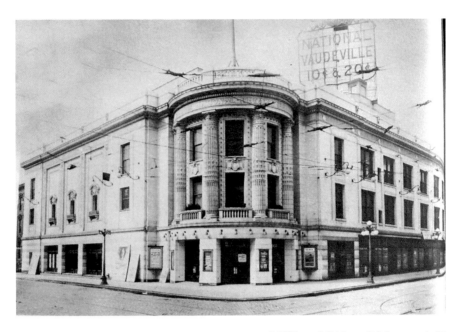

5. The National Theatre on the southwest corner of Fifth and Walnut (Muhammad Ali Boulevard) opened with considerable fanfare in 1913 to both live theatre and vaudeville. It was known for its fine acoustics and excellent box seats. *Courtesy of the University of Louisville Photographic Archives.*

6. In 1952, James Graham Brown purchased the National and demolished it to build a "parking garage" to serve his Kentucky Hotel across the street. The garage was never built, and the surface parking lot has now been there for fifty-five years.

PART III

The Physical Landscape

THE CHANGING LANDSCAPE

In the view of Fourth Street looking north from Broadway from a postcard in 1910, the street is virtually all residential other than the Renaissance-style post office. The demographics of the area from Third to Sixth Street took a major shift from the city's early history until around 1915, when the landscape began to change dramatically.

The original conception of the town included Main Street, not as the marketplace but as the street that essentially warehoused goods brought from the steamboats (and later by rail) by way of the wharf, to be disseminated throughout the city. Market Street served as the center of commerce, with the street exceptionally wide to allow for street vendors on both sides. Jefferson Street was the center of government and jurisprudence. Green Street (now Liberty) marked the beginning of the residential areas, which essentially ended at Broadway (also known as Prather Street and, for a time, Dunkirk).

The area today known as Old Louisville from a historical standpoint might even be referred to as New Louisville. From Broadway approximately two miles south to where the Southern Exposition opened in 1883 was largely rural at the time. Most of the land that the exposition occupied was not even annexed to the city until 1868, ninety years after the city's founding.

THE HENRY CLAY HOTEL

The Elks Club opened in 1924 at the southwest corner of Third and Chestnut Streets. The eight-story building had been exquisitely designed by the local

architectural firm of Joseph & Joseph. Within four years, the Elks realized the huge costs associated with it and alternatives were considered. In 1928, it became the Henry Clay Hotel, operating as such until taken over by the YWCA in the 1960s. The building sat empty and aging not so gracefully since the YWCA abandoned it in 1988.

What has happened between then and 2005 is a series of promises made and promises not kept. Developers with great hopes and out-of-town investors with expansive plans came and went, yet it continued in a downhill slide. That has now come to an end.

Bill Weyland is a local developer who has his heart and soul in downtown Louisville and has a proven track record. His two outstanding successes are the Hillerich and Bradsby Bat Museum and the Glassworks Building. He has now taken on the challenge of restoring the Henry Clay Hotel. While this venerable building at Third and Chestnut is finally in good hands, this project has been an enormous one, requiring a great deal of funding.

Several years ago, before the current renovation, I was allowed, camera in hand, to spend several hours inside the so-called YWCA building (Henry Clay Hotel). I was quite impressed with what I saw. The main ballroom on the second floor has a beautiful stage and hardwood floors throughout. This room has experienced little decay and looks almost as though it could be used for an event. On the third floor is a magnificent lodge room, left over from the fraternal period of the Elks Club. This room has been virtually untouched since its original use and needs serious repairs. The nearly thirty-foot columns are very impressive.

The Henry Clay Hotel at Third and Chestnut Streets.

I uncovered other ornate columns with beautiful relief work. Some of these pillars were enclosed during the YWCA period, which was probably a blessing.

This building has immense possibilities. As of this writing, the restoration is just about complete. Stores are beginning to occupy the street-level space; the beautiful lobby has been restored to its original grandeur. The ballroom and lodge room are completely refurnished. The upstairs portion is divided into condominium and office space. This is an attraction worth visiting—one of the many architectural gems in our downtown.

Mr. Weyland's intervention was not a minute too soon!

THE JAMES IRVIN–K&I RAILWAY HOUSE

Famed songsmith and steamboat writer Will S. Hays wrote a poem entitled "House by the Gate" about a residence that once had a spectacular view of the Ohio River and the Portland Canal.

This house by the gate that Hays describes is adjacent to the K&I Bridge, the Portland Canal and the McAlpine Locks at 2910 Northwestern Parkway. It is a most unusual home, one that very few Louisville residents know exists. This residence has received little attention and has never been a part of any historic home tour. This home, the James Irvin–K&I Railway House, is tucked away in a historic but little-known part of Louisville. It is at the end of Northwestern Parkway, adjacent to the flood wall and the railway tracks of the current Norfolk-Southern freight line. The Louisville Riverwalk passes just in front of it.

The James Irvin–K&I Railway mansion.

The Irvin mansion's entrance hall.

Enoch Lockhart built the house in the 1850s. Lockhart was later the superintendent of the Louisville and Portland Canal's expansion in the late 1860s. In the late 1860s, Lockhart sold his home to Captain James Irvin, who had previously operated twenty-five steamboats and spent much of his time on the Tennessee River. When Irvin left the river and came back to Louisville, he became active in banking and finances.

The house's original site covered about three acres, of which about one acre survives today. When Irvin purchased the Lockhart home, he expanded it to nearly six times the original size. To accomplish this, he hired Henry Whitestone, a leading Louisville architect of the day, to design the addition.

The home now has an interior space of some nine thousand square feet.

One key design element in Whitestone's Italianate expansion was the extensive use of wrought iron around porches and outside areas. Irvin had spent a considerable amount of time in New Orleans during his steamboat career and was influenced by the French Quarter's architecture.

From 1900 to 1910, the Kentucky and Indiana Terminal Railroad leased the home from Irvin's estate for its executive offices. The railroad purchased it in 1910 and remained there until March 1982. The abandoned structure subsequently fell on hard times. It remained unoccupied until 1998, when Naila Jumoke purchased it for use as a restaurant and coffeehouse, called the Java House. When it became available for sale again in 2003, Jack and

The Physical Landscape

Sandra Miller Custer purchased it. They are making a serious commitment to restoring it to its original grandeur.

The Custers are eminently qualified for the task. Jack and Sandra are both lovers of history. They are particularly interested in steamboat history. Together, they authored articles on Captain Mary Millicent Miller and Captain Francis McHarry for the *Encyclopedia of Louisville*. Sandra is a descendant of Captain George Miller, Captain Mary's husband. Jack is the third cousin of General George Custer of Little Bighorn fame.

The Custers took an interest in the property as far back as 1985, but at the time, the Southern Railway only wanted to lease the property. When it became available in 2003, the Custers could resist it no longer and purchased it.

Describing this home's interior could be the subject of an entire article. The inside has elaborate trim work surrounding the eleven-foot-tall doors. The average ceiling height of the two floors is thirteen feet. Four fireplaces remain of the original twenty.

There are two huge vaults with steel doors, one on each floor, which the railroad used for its documents. Either one of these vaults could be utilized as a library or study. The second floor has an incredible room that is thirty by sixty-five feet in size. Jack and Sandra plan to make this room into a library.

Much of the inspiration behind the mansion's architecture came from New Orleans.

Restoring this complex home could be deemed a work in progress. There is an inherent joy in the discovery of the myriad twists and turns that the home has taken during the course of nearly 150 years. As different construction materials have been developed and building techniques changed, it allows one to date modifications and additions. To those with a keen eye for history, such as the Custers, this all comes as a welcome challenge.

Stay tuned!

Thanks go to Jack Custer for providing me the pleasure of a tour of this venerable home and for his invaluable assistance with this article.

THE MADRID BALLROOM

The late 1940s marquee said it all: "Bluegrass Jamboree—Wednesday Nights, Duke Ellington Saturday." The Madrid was a place where you could hear it all—there was something for everyone.

The Madrid Ballroom, later the Club Madrid, was located on the third floor of the Madrid Building at 543 South Third Street at the southeast intersection of Third and Guthrie. The Madrid building also housed the Madrid bowling lanes, which were popular at the time. The complex was served by the huge attached Madrid garage located just behind.

The Madrid was known as "The Place to Dance" when it opened on October 1, 1929, to the sounds of Jan Garber and his Columbia Recording Orchestra. The admission was "one dollar and a quarter" per couple. During the first ten years or so, the Madrid was home to some of the great dance bands of the period, mostly the famous traveling bands or "territory bands," which worked a several-state circuit. A regular at the Madrid was Louisville resident Clyde McCoy of "Sugar Blues" fame with his orchestra, and the perennial favorite, Paul Graham and his "Graham Crackers." With its beautiful dance floor that measured one hundred by fifty feet, couples of all ages filled the club. It became popular for company events and senior proms, and for a time the dance floor even became an ice skating rink and revue featuring the famous Dot Franey and Harry Douglas with their skating novelties, accompanied by Larry Funk's Orchestra. To accommodate dancers during the ice revue period, the ice would be literally "covered over" by a portable dance floor for dancing after the ice shows. During World War II, a special permit was granted to the Madrid to allow so-called swing-shift dances so that war plant workers could have a dance hall available to them until 5:00 a.m. for their recreational enjoyment.

The Physical Landscape

Right: The Madrid
Ballroom marquee.
*Courtesy of the University
of Louisville Photographic
Archives.*

Below: Ballroom dancers.
*Courtesy of the University
of Louisville Photographic
Archives.*

In the years during and directly following World War II, many changes came to the Madrid. Instead of being a dance hall only, the Madrid became something of a concert venue, venturing outside the dance realm. In 1943, the famous Shep Fields Orchestra starred at the club, followed in June 1944 by Lionel Hampton, which broke nearly all attendance records at the Madrid. Hampton and his "hot music" was a huge success. With Hampton was famed pianist/organist Milt Buckner, who returned to Louisville over the years, extending into the 1970s to perform at the WHAS Crusade for Children with Mel Owen's Crusade Orchestra.

In the summer of 1944, a new liquor law was enacted called the "200 feet rule" that required establishments serving alcoholic beverages to be outside of a 200-foot perimeter. The Club Madrid lost its license because it was closer than 200 feet to the nearby Trinity Temple. This limited the Madrid to serving setups only.

In May 1946, the estate of Hugh J. Caperton sold the Madrid complex for some $400,000 to Edward and Yancey Altsheler. Even though the Club Madrid remained open until 1952, the nature of large clubs and ballrooms had changed, and the public's enthusiasm for big band music was on the wane.

The Madrid Ballroom. *Courtesy of the University of Louisville Photographic Archives.*

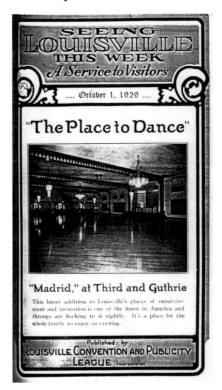

The Madrid was known as "The Place to Dance" when it opened on October 1, 1929. *Courtesy of* Seeing Louisville, *the Louisville Convention and Publicity League.*

Also in May 1946, probably unrelated to the above, was what appeared to be one of the many famous breakups of the Dorsey Brothers Band. Without reason, partway into its engagement at the Club Madrid, Jimmy Dorsey's band suddenly flew the coop, leaving the club in a dilemma to fill out its schedule. Local acts such as the Fredric and Eloise team and others were hired to fill out the period.

After the Club Madrid closed in 1952, and the adjacent bowling alley shortly thereafter, the Madrid building was remodeled to house the new FBI division headquarters, which had been located in the Federal Building. The new suite, some 9,400 square feet, was located on the second floor, which included an extensive records room and a vault that housed an arsenal of rifles, pistols, Thompson submachine guns and other weapons. The area also housed a communications center for shortwave radio and a photo laboratory.

The Madrid building stands today as an important monument to Louisville history. Somewhere within its walls there could still be a trumpet mute or saxophone reed, testimony to its twenty-three years of big bands, gala events and great ballroom dancing.

The Mengel factory at 1247–99 South Twelfth Street.

The Mengel factory before demolition.

The Physical Landscape

DEMOLITION OF THE MENGEL FACTORY

They owned a fleet of steamships, including the famed *Lieutenant Sam Mengel*, a four-masted wooden schooner.

They operated a company town in Tennessee named Mengelwood. This company was the essential reason that Curtiss-Wright aircraft company located in Louisville, Kentucky, during the Second World War—to build the then "top secret" wooden cargo plane. The Mengel Box Company was synonymous with wood and custom wood fabrication. The Mengel family—Clarence, Charles and Herbert—were among the captains of Louisville industry.

The castlelike fortress located at 1247–99 South Twelfth Street, the last remnant of the Mengel empire, has been demolished. This building, placed on the National Historic Register for its Romanesque architecture and structural integrity in 1983, is now part of our history.

In spite of efforts by the Louisville Historical League and by preservationists, the owner, the Sud Chemie Company, had no interest in saving any part of the building. Once more, we lose the battle to save an important part of history.

OPEN-AIR THEATRES

A theatre gem of our city is known as MTL or Music Theatre of Louisville, the moniker that represents the theatrical production component of Iroquois Amphitheatre. Under the direction of Peter Holloway, MTL is providing for our citizens a robust series of programs that rival productions in New York City or Chicago, at a fraction of the cost. The most recent musical, a "song and dance extravaganza" entitled *42nd Street*, lived up to its billing. Written by Michael Stewart and Mark Bramble, it features the music of one of the great Tin Pan Alley writers, Harry Warren. A cast of over thirty actors, singers and dancers and a music ensemble of nineteen local musicians propelled this production to live theatre at its best.

Open-air theatre in Louisville has a long tradition. The first theatre of note was William F. "Cap" Norton's Fireworks Amphitheatre, which opened in 1886 next to his famed Amphitheatre Auditorium, in the area just adjacent to today's Kensington Court. It was built from furnishings and other materials removed from Louisville's Southern Exposition (1883–87). With a 400- by 250-foot stage, the amphitheatre, with its associated pyrotechnics, was able to produce such spectacles as *The Last Days of Pompeii* and the Russian military extravaganza *The Burning of Moscow*. Norton's theatres closed in 1904.

With the invention of the motion picture around 1910, open-air theatres referred to as airdomes began to appear. Louisville had more than fifteen of these, most notably the Palace and the Westonian. These theatres were created before the widespread use of air conditioning and were usually located adjacent to an enclosed motion picture theatre. During the warm summer months, the airdomes would combine live skits and movies. As the fall weather approached, the theatre would move "inside." Many of the airdomes would show the same picture but in different parts of the city. Motorcyclists would "shuttle" the various reels of film from theatre to theatre, hoping for an uninterrupted full-length feature.

The Phoenix Hill Park with its beer garden was popular for open-air evening entertainment some fifty or more years before the Iroquois Amphitheatre. Even at the entrance to Iroquois Park itself, a private enterprise known as Summers Park supplied summer patrons with vaudeville entertainment. Gypsy Village, located at Fontaine Ferry Park, was an open-style summer theatre that provided entertainment for many years.

The idea of outside gardens for entertainment was popular as well. Both the Seelbach and Brown Hotels had "roof gardens" on which open-air concerts and dances took place. On Bardstown Pike (now Road) the popular Inn Logola, with its huge open-garden area for dancing and entertainment, operated for many years. Just adjacent to Iroquois Park (formerly Jacob Park) there were two open-air venues for big bands and entertainment. These were Colonial Gardens (as of this writing, the building is still extant), located on New Cut Road at the intersection with Kenwood Drive, and Iroquois Gardens at 5306 New Cut Road, located adjacent to the park.

The Iroquois Amphitheatre opened following much fanfare on July 4, 1938. A group of business owners, music and theatre lovers and other interested parties had formed some fifteen years earlier. It was known as the Louisville Park Theatrical Association. Plans were formulated for an open-air location for summer theatre, calling for "light operas" (sometimes known as "summer operas") for the opening season.

Optimism ran high. With an ample supply of labor of some 350 men provided by the Works Progress Administration (a federal incentive program following the Depression), combined with Park Board workers, the work was completed in just seventy days, with a work schedule that ran from 4:00 a.m. to midnight. The 3,400-seat theatre, stage, orchestra pit, dressing rooms and outside landscaping were all finished ahead of schedule. The total cost was less than $50,000.

John Shubert of Shubert Productions was hired to head the production department. Fortune Gallo, managing director of the San Carlo Opera

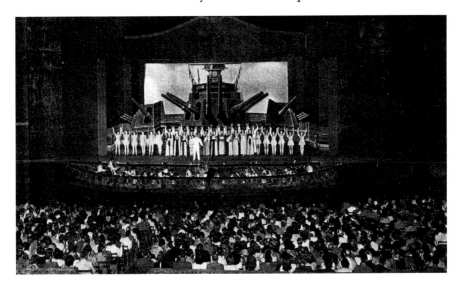

The Iroquois Amphitheatre, 1948.

A Summer Light Opera advertisement.

Company, became director. The 1938 season opened with four leading "operas," each to run one week. Bernice Claire stared in *Naughty Marietta*, the opener, on July 4, 1938, followed by Hizi Koyki in *The Mikado*, Lee Whitney in *Rose Marie* and Metropolitan Opera star Lucy Monroe in *Rio Rita*. In 1938, a season ticket cost $5.00, with individual event seats available from $0.35 to $1.25!

Although the theatre operated at a yearly deficit of as much as $14,000 for the first few years, by the 1941 season, things began to change.

A young but energetic and well-known theatre director by the name of Frederick De Cordova from New York City was hired as producing director beginning with the 1942 season. His assistant director was Alfred Bloomingdale, grandson of the founder of the famous department store. To complete this winning combination was Giuseppe Bamboschek, conductor of the Metropolitan Opera in New York, who was hired as musical director.

Beginning with the 1940 season, summer subscriptions began to increase, with attendance totaling some ninety thousand.

With the start of the war, a special fund was set up by Louisville business owners to allow soldiers to attend for free. The theatre has operated consistently since its opening with the normal ups and downs of the theatrical experience. Weather has always been a determining factor. The war years were a difficult time for theatres. In 1945, all shows were cancelled due to wartime restrictions.

Upgrades to the theatre have required it to close for short periods. The stage was completely rebuilt in 1947. In 2000, the theatre received an $8.9 million renovation, which was completed in 2003. It included the addition of a roof and other amenities. The future looks bright for the Iroquois Amphitheatre, a facility that adds greatly to the vitality of life in Louisville.

THE CITY BELOW

A sewer worker is like a brain surgeon; we're both specialists.
—Ed Norton, sewer connoisseur, played by
Art Carney on *The Honeymooners*

We generally don't expound much on sewers; they are seldom discussed at cocktail parties or sports bars and can hardly be described as glamorous. They perform their tasks efficiently and silently, year after year—unless, of course, you were in Louisville in February 1981. Suddenly, "exploding sewers ripped through streets, shot manhole covers into the air and knocked people out of bed. Authorities said a chemical leak from a nearby plant may have been the cause of the explosions which resulted in the dumping of 60 million gallons of raw sewage a day into the Ohio River."

We tend to take sewers for granted, moving wastewater to treatment plants in different parts of the city and keeping effluent and waste matter in a place where it can be out of sight and, of course, out of mind.

A fascinating book entitled *Final Report of Commissioners of Sewerage of Louisville* was published in 1942, which describes in detail just what makes the city of Louisville sewers do the job that we take for granted. It is replete with the parlance of sewer engineering: outfalls, trunk lines, interceptors, elevations, honeycomb, catch basins and more.

Then there are the specific job descriptions: commissioner, chief engineer, consulting engineer, construction engineer, senior inspector, junior inspector

and rodman (one who moves rods for a surveyor to establish elevation or location coordinates).

This hardcover book, precisely printed on coated (glossy) paper, contains numerous engineering illustrations, fold-out maps and guides, myriad numbers of photographs, specifications and sewer analysis covering some 894 pages. It is obviously the product of countless hours of careful research and meticulous detail. In reviewing the text, it becomes apparent that the science of sewers is one that demands respect. Those who construct these vast labyrinths obviously have knowledge and skills commensurate with Ed Norton's analogy to a brain surgeon.

As shown in the illustrations in this section, Louisville's main sewer lines would easily accommodate a subway system or locomotive. The interior dimensions of these inverted egg-shaped sewer lines (called outfalls) measure eighteen feet, four inches wide and twenty-seven feet, six inches tall. They are located as deep as sixty feet below grade in some places. It is quite amazing that so much of this was built in a time when human labor was the major driving force. The huge earth-moving machinery that we depend on today simply did not exist during the time.

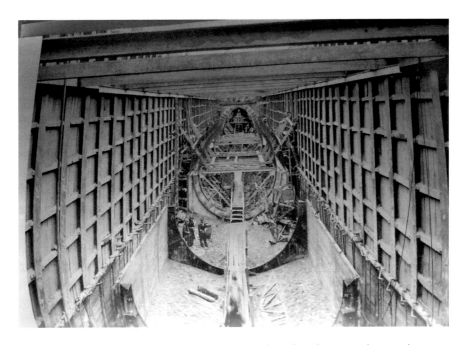

The construction of the sewer and this inverted egg-shaped section was quite complex.

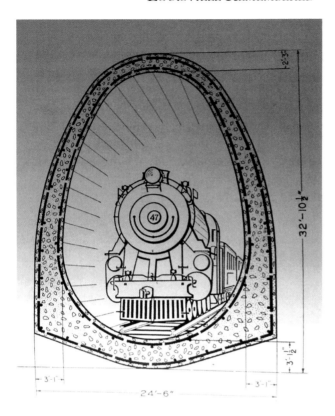

Left: The locomotive in this illustration gives a sense of the scale of the main sewer outfall.

Below: A completed section of the sewer during a public inspection.

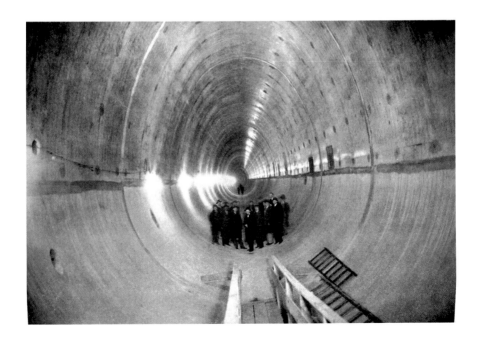

The Physical Landscape

The Metropolitan Sewer District (MSD) publication, *Fifty Years of Service*, offers some important history on Louisville's sewer system, which evolved slowly, partly because of the city's original location, in a pond-dotted bottomland along the Ohio River. In 1805, at Louisville's request, the state legislature passed the "Hog and Pond Law," which set out to ban free-roaming pigs from the muddy dirt streets (Charles Dickens talked about those streets when staying at the Galt House) and to drain the water from the stagnant and stinking ponds. The malaria epidemic of 1822 and other health issues led the community to realize that stagnant ponds and swamplands were part of the problem, and they needed to be drained. This started first with drainage ditches. These ditches and local streams served as the city's first sewer system.

The system as we know it today had its genesis sometime in the decades just before 1850. By 1906, the city had appointed a commission known as the Commissioners of Sewerage to build and regulate sewers. The commission, as outlined in this 1942 publication, did its work well and helped to create the elaborate system that we have today. In 1946, the commission was replaced by what was to become the Metropolitan Sewer District. Today, Louisville's sewer system might be deemed a work in progress because of the constant efforts required to adapt to an ever-expanding population.

Thanks to H.R. "Bud" Schardein Jr. for assistance with this material.

SKYSCRAPERS

After September 11, 2001, the expected decline in the interest for tall buildings never occurred. Peter Malkin, who manages the Empire State Building in New York City, has signed thirty-eight new leases; thirty-two tenants have renewed their leases and nine tenants have expanded their space. Only six tenants left the building as a result of the terrorist attack. The current boom for tall buildings extends worldwide, with extensive growth in Asia. The prospect of the new Museum Plaza stirs excitement here in Louisville.

Currently, skyscraper construction is "on the rise." The new Trump Tower in Chicago, although scaled back, is under construction at 92 floors. The Shanghai World Financial Center, with 101 floors, is due to be completed in 2008, and new construction is either proposed or under development in virtually every major city.

Louisville has certainly had its share of design ideas, proposals and building construction since the six-story Kenyon Building was built (1885), which was

Louisville's first "skyscraper." The Columbia Building, built in 1888 with ten floors at the northwest corner of Fourth and Main, was probably the first building to create a "skyline" for Louisville. The fifteen-story Washington building (Lincoln Savings Bank) on the northwest corner of Fourth and Market, with its lion-head gargoyles around the upper perimeter (1906), was one of the most beautiful buildings in this city.

One must keep in mind that using the number of floors as an indicator of building height can be erroneous since most buildings from the late 1800s into the early 1900s had ceiling heights of ten to twelve feet. The desire to create additional square footage and more floors brought that figure down to around eight feet.

The twenty-three-story Vencor tower, proposed in 1993, is one recent example of a skyscraper that never happened. Two other buildings in this category are worthy of mention. One was never built and the other fell short of the intent of its builders. Both were competing for the same medical/dental marketplace.

Plans were announced in the spring of 1929 by the United States Realty and Improvement Company of New York to erect a twenty-story building called the Physicians and Dentists Building. The building was to be located just south of the Heyburn building on Fourth Street between Broadway and Library Place. It would have been Louisville's tallest building at the time. The architects, Holabird & Root of Chicago, designed the famous Board of Trade building in that city. Plans called for removing two three-story brick residences. An alley north of the Louisville Free Public Library was to be widened into a thirty-six-foot street. The grand plans called for a telephone exchange with twenty-four-hour service and a modern hospital unit complete with operating rooms and a parking garage. The building would be managed locally and operate under the auspices of the Jefferson County Medical Society and the Louisville District Dental Society. When the plans were first announced in February 1929, the only opposition was the choice of the contractor, opposition which came from the General Contractors' Association of Louisville because local firms were excluded from the project.

By May 1929, it seemed like a "done deal." The Consolidated Realty Company, the firm handling the project, stated that more than half of the floor space in the proposed structure had already been leased. In August of that same year, the announcement was made that groundbreaking was to take place on October 1. All parties had signed off with only "minor" details to be worked out. Obviously, it never happened and the logical conclusion points to the stock market crash later that year. The hoopla came to an end and nothing was ever published after the August announcement.

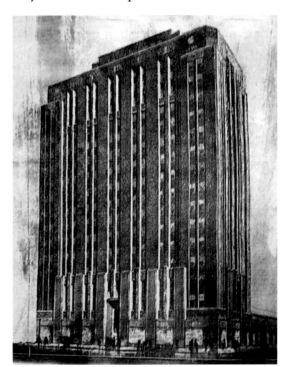

The proposed twenty-story Physicians and Dentists Building.

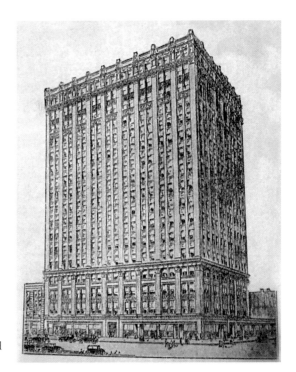

The Breslin Building, proposed at fifteen floors.

The Breslin Building, developed by local contractor Frank G. Breslin, was designed by the local architectural firm of Joseph & Joseph. It was also built to attract the medical community. The building was erected just adjacent to the proposed medical tower on the northwest corner of Third and Broadway. Plans called for the building to be fifteen stories with an Italian Renaissance style.

The building was built in 1927 but was seriously hampered by financial problems from the start and ended up being only six floors. One year later, a two-alarm fire further complicated the financial woes of Mr. Breslin when an electrical shaft erupted and the fire had to be fought from the top down, saturating all six floors of the building!

We look forward with excitement to the prospects of new downtown construction. Unfortunately, as these examples illustrate, many factors come into play to change plans.

Most of us are optimists at heart; we push forward to enjoy those projects that become reality.

THE SAR MEMORIAL FOUNTAIN

Several years ago, I came across a reference in a book entitled *Louisville Panorama*, written by R.C. Riebel concerning a historic fountain that was erected by the Kentucky Society of the Sons of the American Revolution in 1912. It was erected near the intersection of Twelfth and Rowan Streets to mark the location of the "Fort-on-Shore," Louisville's first settlement on the mainland after leaving Corn Island in the Ohio River.

I drove to this location, now an obscure warehouse district just west of downtown. Rowan Street at this point is cut off on the east by the Ninth Street interchange and on the north by a floodwall. After a search, I located what little is left of the fountain, which is shown in the photo herewith.

The little that remains is enveloped in brush, debris from runoff and litter of all kinds—testimony to years of neglect from the time that it was vandalized, sometime before the 1950s.

For more on this fountain, I contacted Michael Christian, librarian at the SAR headquarters here in Louisville. He was most helpful in providing me with a publication entitled *A Century's Service*, a Sons of the American Revolution book outlining its activities from 1889 to 1989, written by David L. Riley.

The Physical Landscape

The Sons of the American Revolution (SAR) Memorial Fountain was erected in 1912 to commemorate Louisville's first mainland settlement, Fort-on-Shore. *Courtesy of the R.C. Ballard Thruston Photograph Collection, the Filson Historical Society, Louisville, Kentucky.*

This book describes the memorial fountain:

> On 24 June 1912, members of the KYSSAR dedicated a drinking fountain located on the south side of Rowan Street a short distance east of 12th Street, indicating where the first building in Louisville stood.
>
> A bronze tablet detailed the "Fort-on-Shore" stockade built 1778–79 by Col. Richard Chenoweth, on orders from Gen. George Rogers Clark. The fort was occupied by troops of the American Revolution for the next four years.
>
> The fountain was a heavy bronze basin 3 feet in length by 2 feet in width, standing on a pedestal and base that brought the surface of the water about 30 inches above the level of the sidewalk.
>
> At each end were "approved sanitary drinking fountains" for humans, and the base had channels permitting drinking by dogs and smaller animals.

After researching the fountain and posting an article concerning it in the newsletter of the Louisville Historical League, I was contacted by James

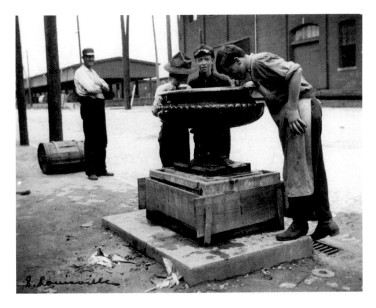

The SAR Memorial Fountain. *Courtesy of the R.C. Ballard Thruston Photograph Collection, the Filson Historical Society, Louisville, Kentucky.*

Today, all that is left of the fountain is its deteriorating base.

The Physical Landscape

Holmberg, curator of special collections at the Filson Historical Society. He was able to locate two photos taken in 1912 when the fountain had just been erected (notice that the forms are still in place). Needless to say, I was pleasantly surprised by his find. Many thanks to Jim for locating these two photos from the Filson's R.C. Ballard Thruston photograph collection.

This is a most important location in our city. The Fort-on-Shore built on this site represents the first actual settlement on land that would become the city of Louisville. Fort Nelson, just adjacent to this location, near Main Street between Seventh and Eighth Streets, was a much larger and more robust structure but was built sometime later.

Thanks for assistance from Michael Christian, Sons of the American Revolution headquarters, Louisville, Kentucky.

THE WASHINGTON BUILDING

The Washington Building (sometimes called the Lincoln Building because its major tenant was the Lincoln Savings Bank), at fifteen floors, was one of Louisville's earliest skyscrapers (that was back when they had twelve-foot ceilings). The structure was designed by the architectural firm of McDonald and Dodd. It was located on the northwest corner of Fourth and Market Streets. The building resided at that spot from 1906 until its demolition in 1972 to make way for what was touted to be a "handsome $3 million four-story structure...bold and severe." In reality, a Beaux Arts–style, heavily ornamented structure in Roman Imperial and French neoclassical decoration (that truly was "bold and severe") was being *demolished* by the efforts of the "urban renewal" commission (historians might say "urban removal") and a local bank. It was a casualty of the 1970s zeal to tear down and replace with little regard for redeeming historical significance.

Close examination of the Washington Building reveals its outstanding architectural features: beautiful ornamental ironwork façades around the lower windows with exceptional scrollwork. The lion head gargoyles around the upper perimeter almost jump out at you. Somehow it seems to have come down without as much as a whimper from the then fledgling preservation community.

Examples of this kind of demolition can be found throughout the United States. The period from the mid-1960s through around 1975 brought about wholesale destruction of some of the nation's most precious buildings. Sometimes entire neighborhoods were leveled during this blitz.

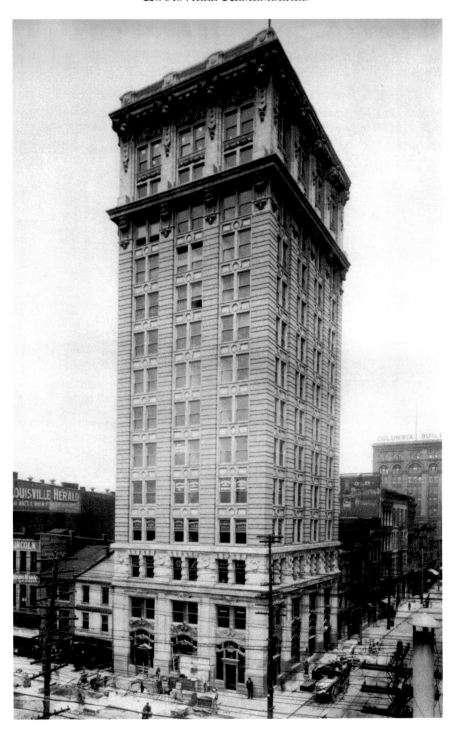

The Washington Building. *Courtesy of the Library of Congress LC-D4-70046.*

The Physical Landscape

Thankfully, there has been a resurgence of interest in preserving historic properties. With groups such as the National Trust for Historic Preservation and local organizations like the Louisville Historical League and Preservation Louisville, buildings like the late Washington Building are better protected.

GRAND THEATRES: THE MAJESTIC AND THE RIALTO

It was an ignominious end in December 1968 as auctioneer Noble Ratts of Indianapolis called for bids on the furnishings and equipment of what had arguably been Louisville's finest and most carefully crafted theatre. The Rialto was about to become part of history. It was to be replaced by—what else?—a surface parking lot.

With the destruction of the Rialto, we experienced the conclusion of opulent movie and vaudeville palaces that were conceived of as an experience in themselves. The act, be it movies or live on-stage performance, was sometimes just an adjunct to the theatre ambience itself. The Majestic and the Rialto were two theatres built on a scale that, with the possible exception

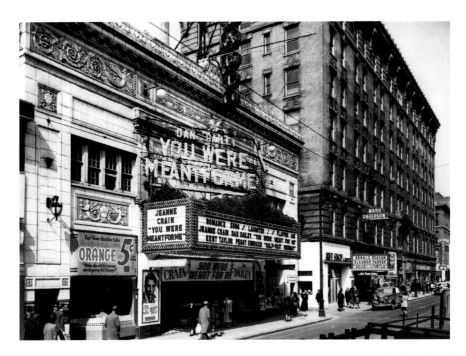

The Rialto Theatre in its heyday. In 1952, the theatre hosted a bout between Joe Louis and Rocky Marciano. *Courtesy of the University of Louisville Photographic Archives.*

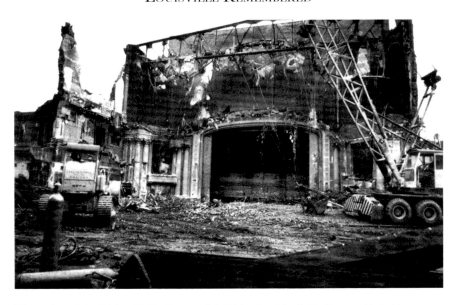

The razing of the Rialto, 1969. *Courtesy of the University of Louisville Photographic Archives.*

of the former Loew's Theatre (now the Palace), will probably never be seen again in Louisville.

Both of these theatres were conceived by Louis J. Dittmar, who wanted to offer Louisville bigger and better venues for vaudeville and the new motion pictures. They were owned by the Majestic Theatre Company, whose stockholders were largely Louisville citizens. The theatres, starting in 1923, were operated by the B.F. Keith circuit and used for vaudeville.

The Majestic (544 South Fourth Street) opened on Christmas Day 1908 for both vaudeville and silent movies. It became very successful and received a complete makeover in 1912, with expanded seating for more than one thousand. The Majestic became the city's first theatre of opulence and had a spectacular circular grand entrance that has been unequaled in elegance to this day. The Majestic overlapped the Rialto and closed in 1928.

"Rialto" is a word dating back to ancient Rome that means a marketplace or place of exchange. There was a trend throughout the twenties in the United States of naming theatres "Rialto." Louisville's Rialto Theatre opened on May 12, 1921, at 616 South Fourth Street after several years of planning and fanfare. The theatre replaced the stately home of William Kaye, which was razed in 1920. The local architectural firm of Joseph & Joseph was commissioned to design the theatre, which was inspired by the famed Capitol Theatre in New York City. C.A. Koerner & Company, a well-known Louisville contractor, was chosen to build the theatre.

The Physical Landscape

The Majestic Theatre opened in 1908 and was designed by Joseph & Joseph Architects. *Courtesy of the University of Louisville Photographic Archives.*

The interior details that comprised the Rialto, like these chandeliers made with imported cut glass, radiated elegance.

No expense was spared in its construction, which exceeded $1 million, a vast sum at that time. The design called for a magnificent unobstructed balcony and total seating for 3,500 patrons. There was to be a huge central stage with two side stages for scenic enhancement. The lobby consisted of a fourteen-foot-high staircase made of marble. Three chandeliers adorned the lobby area with cut glass imported from Czechoslovakia. Vases and figures imported from the Orient were carefully placed. A thirty-piece orchestra, the Rialto Symphony Orchestra, was featured. A magnificent pipe organ was built in the theatre.

In its forty-seven-year span, the Rialto hosted appearances by the greats: Gilda Gray, Ted Lewis and Bob Hope. Irene Dunn made a personal appearance to promote a movie. Cinerama made big news at the Rialto, and *The Sound of Music*, with Julie Andrews, ran a record sixty-four weeks. The Rialto even hosted a closed-circuit television fight between Joe Louis and Rocky Marciano in 1952.

In spite of its incredible cost, when the Rialto opened in 1921, the ticket prices were only twenty-five cents for matinee and thirty cents for evenings. It truly was a place that lived up to its name.

THE CITY WORKHOUSE

The first workhouse in Louisville was proposed by Mayor John Bucklin in 1830. It was erected on Chestnut Street between Eighth and Ninth Streets and was used between 1832 and 1845 as a combination workhouse (a place to punish those who had committed minor crimes), alms (poor) and pest (infectious disease) house. The workhouse represented a means whereby the prisoner(s) could repay through penance, a form of work, creating a useful alternative to being simply warehoused in the jail, where overcrowding was a constant problem. It was said to be a place to confine those at labor who did not pay the fines inflicted by the mayor's court, at the rate of fifty cents per day. The workhouse was occupied by both male and female prisoners.

The castlelike fortress that remained controversial almost from the start was built in 1850 on land purchased some years before on the old Cave Hill farm. The superintendent's building (built in 1878) and central cellblock represented an imposing structure located at 1388 Payne Street. The fortresslike structure built on a hill was quite intimidating and could be seen for some distance. The main activity early on was the breaking of rocks for city streets that came from the city's main quarry at Cave Hill. The city had established a brickyard at the quarry and in later years broke rock that was

The city workhouse.

brought in from various other quarries around the area, including Pewee Valley and a 187-acre tract known as Avoca, which was the site of a farm and a quarry. Some of the prisoners were also utilized at a 300-acre farm in Shively that was owned by the city.

The four hundred individual cells were constructed about six by seven feet and contained small cots or hanging bunks. Each cell had one small window that was heavily barred and had a substantial door with an aperture three inches high by five inches wide. The workhouse was equipped with twelve dungeons in the basement, varying in size, for prisoners who became unruly.

Important reforms came to the workhouse in 1919 when Captain Richard H. Hundley became superintendent. He found that the more able-bodied residents were being worked as many as fourteen hours a day. He limited their work to eight hours with an hour and a half out for eating and resting. He remained as head until 1933.

In 1934, when Grinstead Drive was being built and population density in the area increased, residents in the neighborhood obtained an injunction against blasting at the quarry located near the workhouse. Other factors were at work as well, including the public perception about utilizing prisoners for "hard labor" and even the very idea of having "a maximum security stronghold for a minimum security population." With changing views, the confined atmosphere, the extensive use of wood inside the structure (creating a possible fire hazard) and the general lack of facilities for education and reform, it was finally decided to abandon the workhouse.

The workhouse was officially closed on July 31, 1954, when the last fifteen prisoners were transferred to the county jail. On April 30, 1968, a three-alarm fire destroyed the facility.

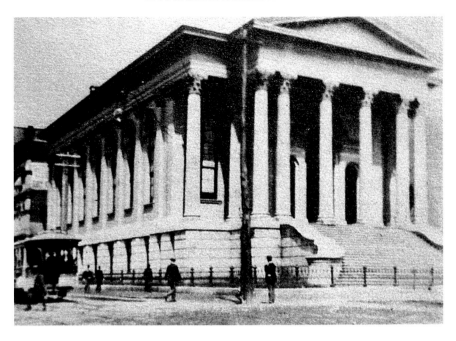

The First Christian Church of Louisville, circa 1910. *Courtesy of the* Louisville Souvenir Scrapbook, *circa 1957, from the South End Optimist Club.*

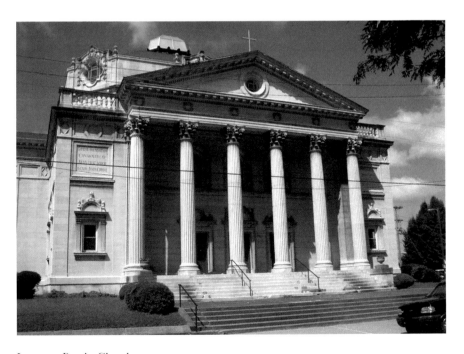

Lampton Baptist Church.

First Christian Church

The First Christian Church of Louisville, located on the northeast corner of Walnut (now Muhammad Ali Boulevard) and Fourth Streets, was razed in the spring of 1912 to make way for the first section of the Starks Building. The Roman Corinthian–style columns were moved and incorporated into the new church at 850 South Fourth Street, now the home of Lampton Baptist Church.

Louisville Sanitary Market

The Louisville Sanitary Market opened on Fifth Street just north of the Cathedral of the Assumption in March 1922. It was an enclosed mall that had the latest in protected food displays and refrigeration units that were furnished by the Cincinnati Butcher's Supply Company.

What would seem a viable concept today only lasted a few months in the 1920s. The site is now a multilevel parking garage.

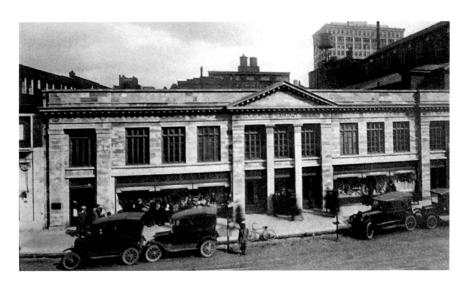

The Louisville Sanitary Market. *Courtesy of the University of Louisville Photographic Archives.*

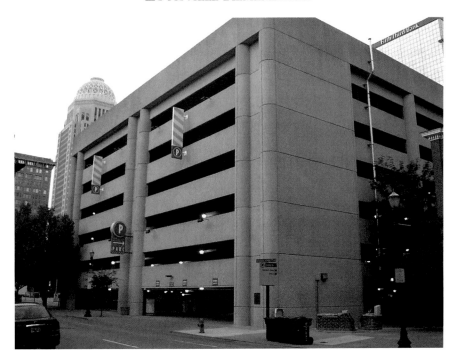

The multilevel parking garage today.

THE WRIGLEY BUILDING AND THE HEYBURN BUILDING

The famous Wrigley Building on Michigan Avenue in Chicago was built in 1920–24 by the architectural firm of Graham, Anderson, Probst and White, with lead architect Charles G. Beersman. In 1927, the same firm and lead architect were chosen for Louisville's Classical Revival Heyburn Building, which was built by William R. Heyburn, president of Belknap Hardware. The firm also designed the Belknap headquarters building and the Starks building annex. A close examination reveals a number of nearly identical architectural elements in the two buildings.

INN LOGOLA

The "log cabin" located at 2919 Bardstown Road has long been associated with the Highland American Legion Post that occupies it today, but this building goes back well into the 1920s and was known originally as Inn Logola.

The Physical Landscape

The Wrigley Building in Chicago.

The Heyburn Building in Louisville.

Newly Decorated and Enlarged

INN LOGOLA

On Bardstown Road

Re-opens Saturday Night,
October 13th, with

MILBURN STONE

AND HIS ORCHESTRA

COUVERT—WEEK NIGHTS 25ᶜ; SATURDAYS 40ᶜ

De Luxe Dinner $1.00 • Club Dinner 65ᶜ

Ed Wetterer, Manager For Reservations, EAst 9122

Building and property purchased for Post Home, 1940
(Ad from 1937 newspaper)

An Inn Logola advertisement, 1930s.

The roadhouse and dance pavilion as it appears today. It is now occupied by the American Legion.

The Physical Landscape

At the time, Bardstown Road was often called Bardstown Pike, and Inn Logola was what was referred to as a "roadhouse"—in this case a huge dance hall with a restaurant and party facility that featured many of the big bands from that era. It functioned as such from the late '20s until at least 1937.

I discussed the matter with Dave Dumeyer, longtime member and historian of the Highland American Legion Post. He provided me with the post's Fiftieth Anniversary program, which featured the advertisement shown on the opposite page. The American Legion purchased the Inn Logola in 1940. The log cabin portion appears today much as it did when it was known as Inn Logola.

THE KIRCHDORFER BUILDING

On the evening of February 15, 2006, the Kirchdorfer Building at 918 Baxter Avenue suffered major damage due to a fire that originated on the third floor. Fire officials determined that the building was still structurally sound, and the building has now been restored to its rightful place in the Highlands neighborhood.

This historic building was built in 1902 by J.C. Kirchdorfer as a hardware store. The Kirchdorfer family lived on the upper floors. J.C. Kirchdorfer's son, Clarence, later replaced the hardware operation with an appliance

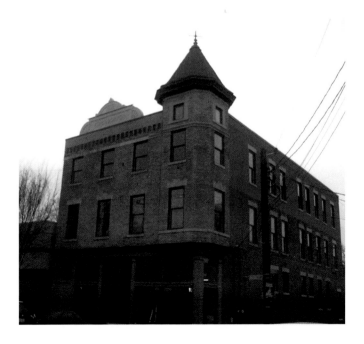

The Kirchdorfer Building, 918 Baxter Avenue.

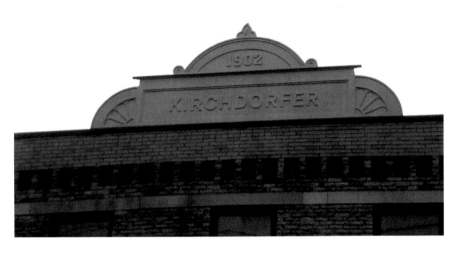

Detail of the sign atop the Kirchdorfer Building.

store specializing in Frigidaire products. The building was later occupied by Beckman Novelties until 1970, when Alcott and Bentley, a firm specializing in wallpaper and fans, located there.

James Kirchdorfer says that much work had to be done to recover from the fire damage and the five feet of water that filled the basement, but the family was determined to restore the building to its original elegance.

This important Highlands landmark, now in its second century, reflects the importance that Louisville citizens place on preserving our local heritage.

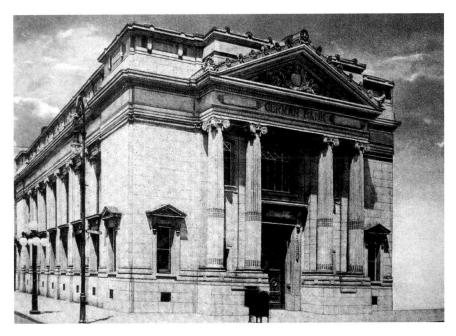

7. The German Bank was located on the northwest corner of Fifth and Market Streets. The name was changed during World War I to the Louisville National Bank. In 1919, the building was occupied by the Federal Reserve Bank of St. Louis. The facility was expanded in 1925. The Federal Reserve relocated in 1958. The early photo is from a 1915 postcard. *Courtesy of* Postcard Views of Louisville *by Gene Blasi.*

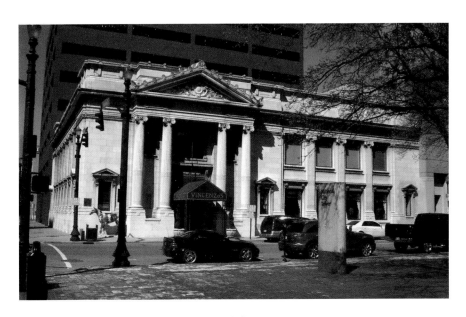

8. This location is now occupied by Vincenzo's Restaurant.

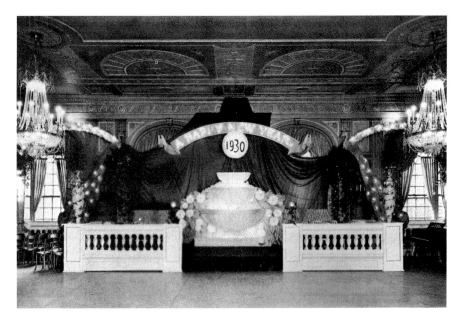

9. The Crystal Ballroom in the Brown Hotel on New Year's Eve 1929, set up to usher in the new decade. *Courtesy of the* Louisville Souvenir Scrapbook, *circa 1957*.

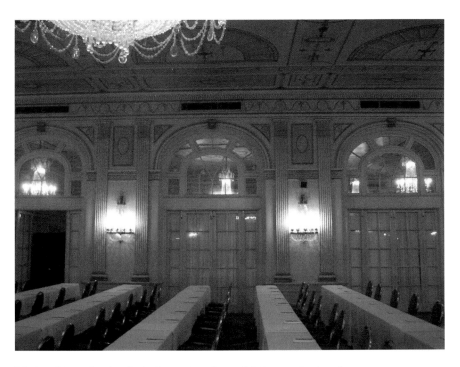

10. As evidenced today, the ballroom has changed little over the decades.

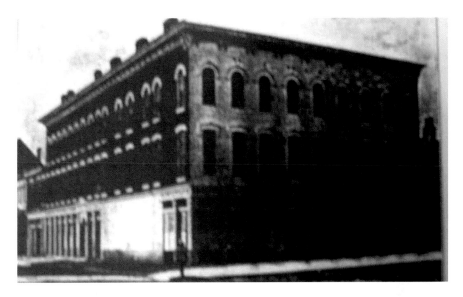

11. The Wulff Building, circa 1880. Under the leadership of W.C. Wulff at 601–605 East Jefferson Street, this company specialized in architectural sheet metal work, which included galvanized iron cornices, skylights, metal ceilings, slate, tile and tin roofing and a specialty of galvanized iron and copper hollow fireproof automatic self-closing windows.

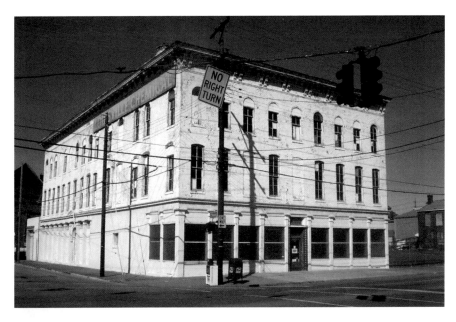

12. The building has become weathered during the many decades since it was built, but it could still enjoy a great future as loft apartments, condominiums or even warehousing. The building was for many years the home of the Louisville Chemical Company. *Courtesy of* Kentucky's Resources & Industries, *Louisville Railway Publishing Company, Louisville, Kentucky.*

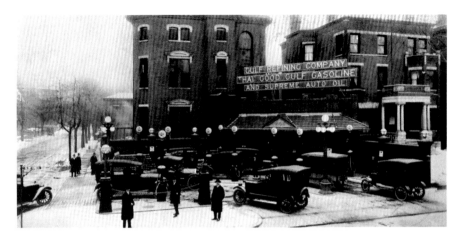

13. The Gulf Service Station on the northwest corner of Third and Kentucky was one of the first stations in Kentucky in 1917. With nine pumps, it was a very popular place. According to a July 22, 1917 *New York Times* article, the president of Standard Oil Company issued a warning that the country's consumption of oil far exceeded production and that pleasure drives should be cut to a minimum due to the need of fuel for the war. In the different territories of America, prices arbitrarily ranged upward from $0.20 ($2.30 in 2007) per gallon wholesale, with huge markups from there at the pump. Some contend that because of the war, 1917 was the most expensive year ever for the real cost of gas.

14. With the corner residence removed, the most notable artifact is the residence to the right with the ornate front porch that appears today much as it did in 1917. An "Ollie's Trolley" restaurant is on the corner. The main building on the property appears to be the same structure (with many changes) as in the earlier photo. *Courtesy of the author, additional text courtesy of Steve Wiser.*

PART IV

Character of the City

"Thunder"—1890s Style

Of course, most of us are familiar with Harry Truman's statement that "the only thing new in the world is the history you don't know." This certainly would apply to the history of fireworks and pyrotechnics in Louisville.

Just before the close of the Southern Exposition in what is now referred to as "Old Louisville," on August 28, 1886, the Fireworks Amphitheatre opened on Fourth Avenue, occupying a full city block extending to Fifth Street and between Hill and A Streets (now Gaulbert) north and south.

The Fireworks Amphitheatre was the brainchild of William F. Norton Jr., a legendary figure around Louisville about whom much has been written.

Mr. Norton was born in Paducah, Kentucky, in 1849 and moved to Louisville with his family. The Norton family was well known in the banking business. Norton worked in banking for a time but decided that life "behind the bars," as he called it, was not for him, so he set about searching for a more illustrious career. At his peak, Norton (who had a litany of nicknames, including the famed Charles Dickens character "Daniel Quilp") had constructed the famed Amphitheatre Auditorium, with a stage second in size only to the original Metropolitan Opera House in New York; a lagoon stocked with ducks and swans around which was placed a bicycle track, six laps to the mile (that Mr. Norton had built at the request of the Louisville Wheelmen Bicycle Club); a deer park; and a summer garden for promenade concerts. All of this was well lit indoors and out with two electric power plants located on the premises. The stage required for the Fireworks Amphitheatre measured 400 feet wide by 250 feet in depth. The bleachers provided seating for ten thousand spectators.

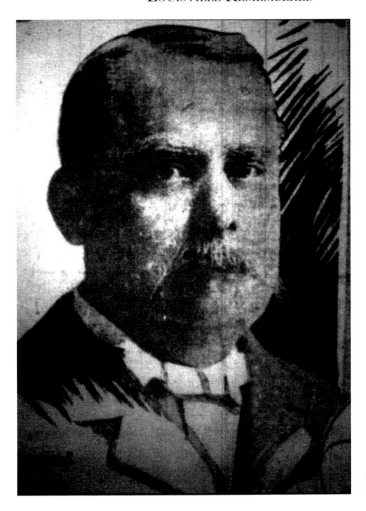

William F. "Cap" Norton Jr.

The first days of "thunder" were enjoyed in amphitheatres like this one, opened in August 1886 on Fourth Street. *Courtesy of the* Courier-Journal.

Character of the City

The original concept behind the Fireworks Amphitheatre was to highlight the pyrotechnics of the famed London pyrotechnist James Paine (sometimes spelled without the "e"), who was conceded to be the "fireworks king of the world." The Paine firm also painted the scenery for the various presentations, which were thematic in nature.

The first production presented in 1886 opened with the romantic spectacle *The Last Days of Pompeii*, which was presented every Thursday and Saturday evening until the season closed on October 23. Over two hundred performers or supporting cast were involved in its production.

In 1887, the production of the grand Russian military spectacle *The Burning of Moscow* ran the entire season, followed by the 1888 production of *Siege of Sebastopol*. The Paine theatrics and fireworks combination proved to be a viable one that, coupled with the adjacent Amphitheatre Auditorium, remained popular until around 1902.

In declining health, William Norton moved to Coronado Beach, California, where he built a fourteen-room home and left the management of his various enterprises to trusted employee James Camp. The entire complex, however, had about run its course, and it was closed by 1903, the year of Norton's death. The furnishings and equipment were auctioned in May 1904.

William "Cap" Norton had a vision for Louisville and for what he believed he could bring to its people. He and his complex of amusements brought a dynamic element to this city, one that lives today in its vital arena of live theatre, music and, of course, pyrotechnics.

A SNAPSHOT IN TIME

A copy of a *Louisville Herald* newspaper dated December 29, 1909, was recently discovered in the attic of a Fern Creek home. It offers a glimpse of daily life in Louisville during the first part of the last century.

In 1903, the *Louisville Herald* succeeded the *Louisville Commercial*, a Republican voice that began publishing in 1869. The *Herald* claims to have been founded in 1832 and reorganized in 1902. It was published by the Herald Publishing Company, which was located at 413 West Market Street, just a few doors west of the Washington Building, located on the northwest corner of Fourth and Market. The Herald building was clearly recognizable by its large painted east wall, which stated, "The truth no matter whom it helps or hurts." The *Louisville Herald* and the *Louisville Post* were combined in 1925 to become the *Herald-Post*.

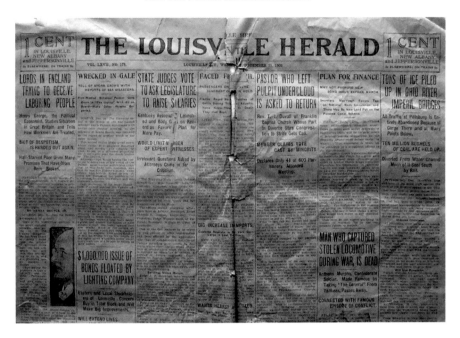

This 1909 edition of the *Louisville Herald* could be purchased for a mere penny.

When reading these early newspapers, some things become evident. One important aspect of the writing during this period was the emphasis on the human interest side of a story. Today we are conditioned to what one might call "raw data"—the statistics and hard facts related to events and situations. Another distinction is the colorful use of the language, particularly adjectives used in the descriptions in these human interest stories. Some of these words seem so unusual that it makes you think that they were just invented by the author. A quick reference to Webster's confirms that words that "jump out at you" were part of normal discourse a century ago.

In boxes both to the left and right of the newspaper name on the front page is the price of the newspaper: one cent in Louisville, New Albany and Jeffersonville, two cents elsewhere and five cents on trains.

Summing up the year of 1909, an editorial stated that there were important strides made concerning women's suffrage. There were also stories such as "A sugar heiress is to marry a plain American who used to work in overalls. Continental snobbery will stand aghast"—after all, this was the Victorian era. Such articles command your attention.

There is curious advertising in this newspaper. Much of it concerns potions and remedies for various ailments. Many contain protracted explanations or testimonies such as, "I cured my rupture" and "I will show you how to cure

yours FREE!" There was no shortage of self-treatment and miracle cures during this era.

One of the big news stories of the day concerned a Highland Park butcher named John Sheydt, who carried out the threat to end his life. He seemed to tell all those around him what he was about to do, but his threats went largely unnoticed. He went to a local druggist, a Mr. C.M. Edmunds, and purchased a vial of carbolic acid. He proceeded to the nearby local tavern owned by C.M. Jones. There he ordered a glass of whiskey and poured the contents of the vial of carbolic acid into the glass and drank it. None of the habitués (customers) of the saloon knew what he had done until they saw him toss something toward a cuspidor and heard the vial strike it. Unfortunately, his sixteen-year-old son, Tommie Sheydt, and a neighbor by the name of Maier were the first to find him unconscious and lying in the street. After he expired, his body was taken to the Cralle undertaking establishment at the corner of Chestnut and Sixth Streets. He was said to have been suffering from melancholia.

There were lots of "travel specials" being advertised. One was a round trip to Chicago by rail on the "Monon" route; price: nine dollars. Some local stores mentioned in the paper included B.B. Watts Plumbing on Fifth Street, Southern Optical Company, Korfhage Watch Repair, Frank S. Cook Lumber, Herman Straus and Sons store, Kaufman-Straus, Lovenharts (Third and Market), Keiskers Furniture and Rugs (313–15 West Walnut Street) and the Hotel Knickerbocker.

So it went as 1909 came to a close.

The *Louisville Herald* building, West Market Street.

THE OLDEST PROFESSION

Like many river towns, the development of the city brought with it many of the vices associated with the hard-driving types who worked on and traveled the routes along the inland waterways on steamboats. As Louisville began to thrive, the twin vices of gambling and prostitution began to flourish.

George Yater, in his article on prostitution in *The Encyclopedia of Louisville*, points out how this activity flourished most during wartime, beginning with the Civil War and at times when there was an encampment of one sort or another serving the military in or around the city.

In the later 1800s, prostitution was concentrated in an area known as the Chute, which was located around the intersection of Floyd and Jefferson Streets. Following this, Green Street (now Liberty) and Grayson Street between Sixth and Tenth Streets became the center of such activity.

Most enduring in the annals of Louisville history, of course, were the Green Street brothels.

As the ebb and flow of public outcry to control prostitution occurred, authorities responsible for enforcing the various ordinances against it would, usually with some degree of lethargy, respond by "cracking down" to one extent or another. Prostitution pretty much flourished during the reign of the famous Whallen brothers, James and John, who maintained a curious mix of political wrangling (particularly within the Democratic Party) and entrepreneurial activity, mostly associated with burlesque and various roadshows. This was a period that lasted from around 1870 through the First World War.

When the federal government's War Department selected Louisville as the location for Camp Taylor as a training site, there was an outcry from other cities regarding the "moral status" of the city. An editorial in the *Fort Wayne News* (Indiana) on July 11, 1917, berated the decision, saying that Mayor Buschemeyer (1913–17) "angrily declines to act on the suggestion that the city's red-light district be cleaned out." Replying to the order of R.B. Fosdick, chairman of the federal commission on training and camp activities, that Louisville "must close her disorderly houses and keep them closed," the mayor snappily replied that "Louisville will do nothing of the sort." According to Mayor Buschemeyer, it would be a shame to turn these ladies out of their homes with no proper places for them to go, and he did not propose to "be a party to any such outrage."

As late as 1969, a federal study listed Louisville along with New York City, San Francisco, Seattle and Washington, D.C., as the five cities with the highest rates of prostitution.

Prostitution persists in Louisville; however, there are no organized districts or high areas of concentration. In recent years, the activity has been closely associated with massage parlors, "adult" bars and the like. During the Kentucky Derby, there is a spike in various vice activities, including prostitution, as an influx of outsiders frequent our hotels and areas of assembly throughout the city.

GYPSIES, FORTUNETELLING AND MORE

The first gypsy bands to make their appearances in Louisville arrived in covered wagons. Around their heads were red bandanas, over their shoulders short ornamented jackets and about their waists yellow or purple sashes. Wearing jewelry was a strong tradition in gypsy culture. Women were adorned with many bracelets and necklaces handed down through generations of gypsy culture. Gypsies became excellent horse traders. Louisville became a convention city for their activities, especially what might be referred to as the "rites of passage." In 1914, Zlaco Dimitro was the head of a tribe of gypsies in the Louisville area. Becoming established in Louisville, both he and his son Frank Dimitro, along with other relatives, achieved a certain level of acceptance and credibility, with only one recorded arrest within the group in three years.

One cannot say that Louisville has a rich history of a gypsy population. In searching for information on the subject, there is little documentation available. Most information that has been written about it is contained in newspaper clippings that, taken together, portray an image of a culture not as a resident group but as traveling nomads who, from time to time, converge on cities like Louisville, usually for some sinister activity such as con games and schemes involving some form of deception. It can be assumed, however, that many gypsies passed through our city by way of carnivals and traveling roadshows.

Because of public distrust of gypsy groups, their "residences" usually consisted of abandoned storefronts away from residential neighborhoods. In Louisville, along Fourth Street between Winkler and Central Avenue, many empty commercial buildings were occupied by gypsies. The tell-tale brown waxed paper covering the windows was usually an indication of a gypsy occupant.

During the 1920s until around 1940, many activities took place in Louisville that were associated with gypsy groups. Louisville became, for a time, a center for gypsy ceremonial conventions because it was conveniently located between the North and the South.

Fortunetelling was a popular industry within the city's gypsy contingency.

Character of the City

In 1929, various gypsy "tribes" convened in Louisville from Cincinnati, Indianapolis, Chicago, St. Louis, Philadelphia and other points to attend one of the most elaborate wedding ceremonies ever staged by gypsies in this country. Somewhere between four and five hundred gypsies visited when a certain Gregory John of Philadelphia and Rosie Stanley of Louisville were married. Pigs, turkeys and chickens were roasted all over town for the feasts. An orchestra was commissioned from Cincinnati to play continuously for twenty-four hours for the event. The wedding took place in a three-acre field near the Ohio River that was filled with pitched tents for the event.

In February 1948, Louisville judge Homer McLellen became a fortuneteller of sorts, since he was able to predict the future of Frank White of Grand Rapids, Michigan, an alleged fortuneteller and operator of various schemes as part of a carnival operation. White was charged with vagrancy.

Certainly, not all fortunetellers or persons engaged in confidence games are gypsies, although gypsies for centuries have been associated with such behavior. The White family or a group of gypsies using the last name of White has been associated with various illegal activities throughout the South. A former storefront that had been a pizzeria at Winkler and Rodman Avenues was long associated with the White family.

One gypsy, Mary Mitchell, known as "Sister Mary," became well known in Louisville in the mid-1970s. Her center of operation was in the 10100 block of Dixie Highway. Sister Mary was a palm reader but claimed to be far more than that. She touted herself as a religious holy woman, God's messenger who could heal the sick and the ailing and remove bad luck from a person's body through her prayers.

Perhaps the last major event to bring a large number of gypsies into Louisville was the death of Leo Mitchell. Mitchell had been the head of the Mitchell clan, which numbered some ten thousand gypsies. At the Bohlsen-Miller and VonderHaar funeral home on Barret Avenue, some 250 gypsies from around the country showed up by plane, bus and car to show their respects.

HOBBYISTS IN LOUISVILLE

In our world of internet, television and sports, little is mentioned about "hobby clubs," as they were known during the last century. Virtually any kind of collection or activity could constitute the basis for a club that highlighted its members and their various accomplishments. There were stamp collecting clubs, matchbook collecting clubs, bottle collecting clubs

(sometimes combined with outhouses), amateur radio clubs, antique clubs, you name it. Schools sponsored clubs—airplane clubs, math clubs, Latin clubs and on and on.

The local press would publish feature articles from time to time concerning the expertise of various hobbyists throughout the city.

One curious feature, in June 1935, was Mr. J.W. Stark's "House of Flames," a miniature eight-room house that he fashioned from some ninety thousand burned matches, a few pieces of wood, shellac and some ten pounds of dry glue! Even the interior furnishings were made from burned matches (something that we would call adaptive reuse in the parlance of today).

During May 22–27, 1939, the Crescent Hill Woman's Club in Louisville sponsored a huge "Antiques and Hobby Show" that was held at the Madrid Ballroom at Third and Guthrie Streets. Hobby club members along with dealers (twenty-eight of whom were from out of state) and some fifty private collectors participated.

There was quite a bit of hoopla surrounding the event, with the press providing considerable coverage of the various displays. This was understandably so—Louisville had never seen a show such as this.

Some of the displays just seemed to jump out at you. Here are some highlights.

Mrs. Robert Cheatham of St. Matthews brought her collection of some one hundred glass and china hats in every style of brim, from sombreros to Lincoln-style stovepipes. These were said to be great for holding cigarettes or candy. Such hats were originally intended to hold salt, toothpicks, spoons or even celery. Toddy-lifters made in the form of hats were popular. They were shaped like firemen's hats, and each had a small hole in the top. When a finger was placed on the hole, the contents of the lifter were retained by atmospheric pressure.

Colonel Lucien Beckner, a consulting geologist of Louisville, brought his collection of twelve prehistoric pipes from the American Indians. One was from "Sitting Bull," the famed Sioux chieftain, but most were discovered in western and central Kentucky. These pipes were puffed around council fires during the mid-1600s by the original Indians of Kentucky, who migrated westward. Mr. Beckner explained that sometimes willow bark and aromatic herbs were smoked in the pipes.

Members of the Louisville Stamp Club brought their precious frames of stamps, which included the first known stamp in the world, placed on sale May 6, 1840. Some stamps displayed were famous because of the recipient of the letter to which they were attached. Two such examples included the actress Jean Harlow and aviator Orville Wright. A Mr. Frericks brought his

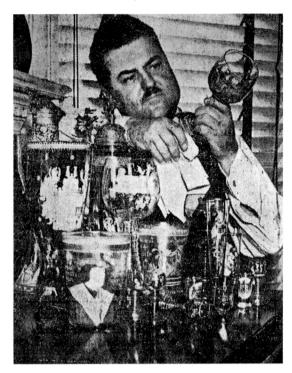

Herman Erhart shows off some of the glassware in his extensive collection of beer steins.

' of 3 Hobbyists Selected
3y WHAS to Go to New York

Three finalists compete in the "Hobby Lobby" contest.

famous collection of Confederate stamps, deemed to be one of the most valuable collections of its type in the United States.

Other notable exhibits included a collection of ancient firearms displayed by A.M. Cowherd. Herman Erhart brought his assortment of beer steins and glass drinking vessels of all types. The antiques and hobby event was a real show and tell.

March 1940 brought the "Hobby Lobby" contest for the Kentuckiana area, sponsored by WHAS. Announcer Jim Walton interviewed the three finalists. The winner, Mrs. A. Luke Brown, who displayed her collection of 1,200 tiny boots, shoes and slippers, was selected to travel to New York City for four days, all expenses paid, to appear on the CBS program *Hobby Lobby*, hosted by Dave Elman. Asked if she thought she might be overcome with "mic fright" on a big program, Mrs. Brown laughed and said, "I don't think so. My husband says it will take more than a microphone to keep me from talking."

GEORGE HAUCK AND THE "WORLD CHAMPIONSHIP DAINTY CONTEST"

In Louisville, the neighborhood known as Schnitzelburg is bounded roughly by the streets of Burnett, Texas, Goss and Shelby—an area at one time defined by the streetcar "car loop." In the late 1800s, the area became home to many artisans, mostly German and Dutch immigrants, who worked in furniture factories that were located on nearby Kentucky Street.

Each year, for the past thirty-four, this neighborhood has hosted a late-summer event known as the World Championship Dainty Contest.

The sponsor of this celebration is a gentleman who is synonymous with the area and of Germantown generally, Mr. George Hauck. Mr Hauck is important enough to this community to have a street named after him.

To fully understand why this is so, one must go back to the year 1912, when Hauck's Handy Store was opened by George's mother, Elizabeth, at the intersection now known as George Hauck Way (Hoertz Avenue) and Goss Avenue. The Hauck family business has operated continuously at this location since that time—nearly one hundred years and still going strong. Originally designated a dry goods store, it sold such things as cloth, buttons, thread, seam binding and embroidery floss. Hauck's also had a "shoe stock," selling a variety of shoes. With the passage of time, it has slowly evolved into something of a general store, selling lunchmeat, beer and a multitude of items of importance to the household.

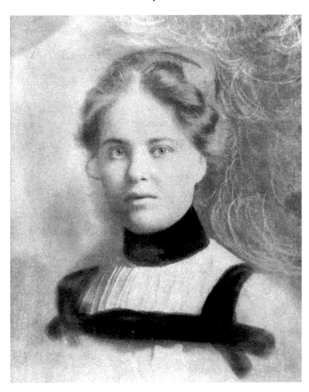

Elizabeth Hauck opened Hauck's Handy Store in 1912.

When you enter Hauck's Handy Store, you immediately feel like you are going back in time. In virtually every nook and cranny is a product for sale. What appears to be the original 1912 cash register still stands proudly in place with a sign above it that reads "Loaning money causes amnesia," certainly good advice for anyone. Many family photos are in clear view. One that catches your eye is of a young (about age twenty-three) Elizabeth Hauck, who founded the store. At one time, Elizabeth and her husband, William, operated three stores in the Louisville area—one in Portland, one on the northeast corner of Shelby and Caldwell and the current store, which is run principally by George and Jean Hauck's two daughters, Karen and Lynn.

In a recent interview, Mr. Hauck affectionately reflected on growing up in this neighborhood and in the Hauck family business. He pointed out how important outdoor activities were to children. He described how youngsters shot marbles and played sundown, shaney and dainty. He feels strongly about how the city landscape today is nearly devoid of children playing street games, much of this being a result of the isolation brought about by video games and television. Nearly thirty-four years ago, Mr. Hauck "reintroduced" the street game of dainty to the area, and even to

Hauck's Handy Store is still going strong today.

George Hauck holds a "dainty."

his surprise, it has become a popular sensation, with one day set aside each year engaging the whole neighborhood to take part.

So, how is this game of dainty played? You have a puck, similar to that used in hockey but made of a six- to seven-inch section cut from an old broom or mop handle. The edges are rounded out, usually with a pocketknife. With the accompanying shortened broomstick as the bat, the player hits one corner of the dainty, sending it up into the air and then striking it, sending it some distance. It is this distance that determines the prize or the points attained. As part of the event, the losers must become part of a "hopping" contest, hopping on one leg the equivalent distance that the winner hit the dainty. In early years, the main prizes were such things as soft drinks and candy, but recently a trophy has been added for the winners.

In today's fast-paced world, it is important to reflect back on what most of us would agree were simpler times—an era when most of our experiences were based on direct relationships with others. This was exemplified by inside games such as chess and checkers and outside activities such as street games and picnics.

Mr. Hauck and his "world championship" dainty contest represent a pleasant look back to a time when kids filled the streets with such adventures.

The Knights Templar Triennial Conclave

The Knights Templar (Temple of Solomon) was formed in northern France around 1127. Knights Templar became one of three groups that were organized as military units. Interest in it soon spread throughout Europe. Over the centuries, the order has had various tasks, from protecting the pilgrims after the first crusade in Jerusalem to being active throughout the crusades in guarding castles, kings and church officials. They were important throughout the Middle Ages. Fraternal groups and Freemasons (which includes shriners) have been a vital part of the fabric of society from the early Middle Ages into the New World of North America.

In the United States, most of the founders were involved in Masonic groups. In most professions, especially the construction trades, they have played an important role. The wealth, politics and social fabric of this country has been influenced by groups such as the Knights Templar. To this day, most U.S. cities, including Louisville, have a chapter.

The 1800s saw a great interest in the Knights Templar in this country. Part of the attraction was the military attire, discipline and adherence to

A Knights Templar advertisement.

basic values of honesty and loyalty. The Knights Templar Order of De Molay is very popular. Jacques De Molay, who was grand master, became a martyr after being condemned by the pope and was executed by King Philip in 1314.

Why the history? It is important to know something about the Knights Templar to understand the ceremony that they have at their various commencements held throughout the United States. From the later part of the 1800s to around World War II, the yearly conventions or "conclaves" were important events in the cities that hosted them. One such gathering took place from August 27 to 30, 1901, in Louisville. It was billed as the Twenty-eighth Triennial Conclave of the Knights Templar at Louisville, Kentucky.

The *Nebraska State Journal* of Sunday, August 25, 1901, described this gala week in Louisville, Kentucky:

> *Immediately after dusk the city became a veritable dreamland of dazzling brilliancy when the electric current was turned on a hundred designs and decorative structures. The entire central portion of the city is tonight flooded with light from myriads of vari-colored incandescent globes. Great Templar crosses and shields adorn the entire fronts of office buildings and business houses. Crusaders and prancing war horses of heroic design constructed of cathedral glass behind which are placed electric lights are conspicuous figures on some of the public buildings. Festoons of colored lights span the thoroughfares of forty different blocks in the heart of the city.*
>
> *A climax to the decorative effects has been reached in the quadruple electric arch of Fourth avenue and Broadway and in the court of honor in front of the Jefferson county court house on Jefferson street, between Fifth and Sixth. The magnificence of the former structure was not realized until its 5,000 incandescent lamps were lighted tonight. Four massive piers carry the structure upward from the four corners of the sidewalks.*

In describing the phenomenal "arch" that spans Fourth Avenue (Fourth Street) at Broadway, the *Journal* continues:

> *The massive dome that arches above the intersection of the two streets is surmounted by a cross and crown, one of the most striking of the templar emblems. The crown is twenty-five feet in diameter and is jeweled in golden lights. The cross is twenty-two feet high and literally covered with scarlet lamps…The interior is centered with a platform heavily banked with plants and flowers behind which an orchestra will play each afternoon and*

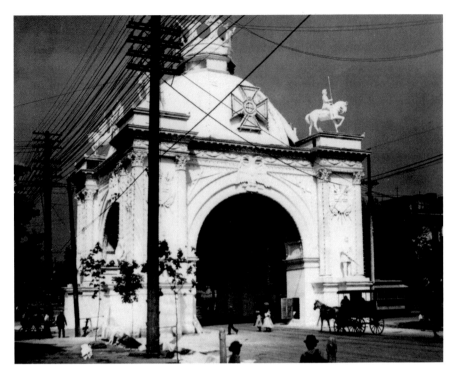

The Great Arch at Fourth and Broadway. *Courtesy of the University of Louisville Photographic Archives.*

evening of the week. Spacious court rooms surrounding the corridors will be used for the different functions connected with the reception.

The article goes on to say that on Tuesday of that week, the great parade takes place. Major John H. Centhars of Louisville, who is an ex-Confederate officer, is the grand marshal of the parade. There will be not fewer than 20,000 templars and 2,600 musicians in line. The parade starts at Seventh and Main Streets and will total around three and a half miles in length. The circuitous path will pass through the great arch and reach its completion in Central Park just adjacent to St. James Court.

It is hard to imagine in the current day how a single event such as this could totally dominate the central part of this city and how downtown commercial buildings and government centers could be adorned with such extravagance.

Just the thought of the permits and variances is mind-boggling. To close Fourth Street at Broadway for what must have been several months would be quite difficult to say the least.

What ever became of the arch? With the amount of effort that went into the construction of the arch, you would be inclined to think that some plan would have been in place to keep it as a monument. I have been unable to locate any information about the huge structure. It must have been a short-term arrangement, though, since extant photos of it number fewer than a half dozen.

The Knights Templar was for many years headquartered at 212 West Broadway. It enjoyed continuing popularity until just before World War II, but there is little mention of it in the press since that time. The Knights Templar hall of today is located on Gardiner Lane near the main post office.

THE TALKING HOUSE

There was a lot of hoopla and certainly what seems to have been some tongue-in-cheek dialogue going on in the early part of 1939 about a house at 2609 Montrose Avenue in the Kingsley Subdivision (now City of Kingsley) in Louisville that was (ostensibly) so unique that it was claimed that some "20,000 persons" would pass through the feature home in the nine-day period that it was open for "inspection."

The time was right in Louisville for such an event. The city had weathered the Depression, jobs were on the upswing and the economy was in revival. The city had rebuilt following a devastating flood just two years earlier. A new spirit filled the air.

Arrangements were made with the police department to handle the huge crowds expected on the peak days of the event, according to the builder. The "Talking House" moniker originated from the fact that a master of ceremonies would be on hand to talk about whatever facet of the house interested those who were passing through it.

A series of articles in the *Louisville Times* in April 1939 outlined the features of this "unique" house. One cannot help but think of the Patrick Hughes *Extreme Makeover* home popularized in Louisville in 2008 when perusing these articles. Obviously, the manufacturers and installers of the interior furnishings were tuned in to the name recognition that would accompany a tour of this structure.

The home was provided an "automatic" heating and air conditioning system installed by the Schock Heating Company. It seemed important that the exterior walls and attic ceiling were insulated with rock wool and the roof had cork insulation. The "rathskeller" had a rubber tile floor. Miss Vance

The Talking House, 1939. *Courtesy of the* Louisville Times.

The Talking House, 2008.

Taylor, a Hollywood scenic artist, completely decorated this novel room. Hardwood floors and red gum trim were used throughout the home.

Cornelius Hubbuch of Hubbuch's on Broadway provided the decorating of the living and dining room that were done in an eighteenth-century motif. Wards furnished the master bedroom in an eighteenth-century Hepplewhite design. They even provided the latest up-to-the-minute De Luxe seven-tube Airline radio as an extra. Robert Shackleton, of the Shackleton Piano Company, provided a Chickering piano as the musical feature of the Talking House (one wonders if it stayed there after the celebration). Plumbers Supply Company installed all of the plumbing fixtures. Of particular note was the Kohler Cosmopolitan matched set of fixtures installed in the bathroom.

Some items were not directly pertinent to the home itself but were somehow included in this huge event. The fact that the builder of the home, a Mr. Lawrence Breitenstein, had for some seven years been driving a Chrysler Royal that offered better than twenty miles to the gallon seemed an important part of the whole affair. According to one article, "equally as important as the home" was the food and dairy products that were being provided by the Ewing-Von Allmen Dairy Company. Included in these products was the latest in "Homogenized Milk" being offered to all visitors. It was said that this milk had incorporated in it all of the latest known scientific developments. Proper financing of the home was being offered by the Kesselring-Netherton Company, which is a specialist in such things.

With today's Homerama and the countless promotions that are so slickly produced, the Talking Home idea hardly seems sensational, but this event certainly did represent a beginning for what would become an industry in itself—the marketing and promotion of new homes.

FALLOUT SHELTERS

Starting around 1942, our government recognized a need to protect citizens from possible invasion from either coast. Following World War II, the cold war with the Soviet Union increased this concern.

Voluntary blackouts during World War II were rehearsed in cities that were considered most vulnerable. Bunkers and bomb shelters (later called fallout shelters) were built as defensive measures. A new designation arose for those who administered such programs: air raid wardens and later civil defense directors and shelter managers were created. A number of agencies such as the Civil Preparedness Agency were established, the precursor to today's Office of Homeland Security.

Cities began to look closely at the resources that were available for protective shelters. For example, in nearby Cincinnati, the unfinished subway system became a shelter. Along with these security concerns, the Conelrad alert program was instituted with its familiar triangle in a circle. "Clear Channel" radio frequencies were established at 640 and 1240 kilocycles (kilohertz) on the AM band for emergency information. Air raid drills were routine in schools and tests of emergency sirens occurred weekly.

Louisville was already considered one of the safest cities in which to find shelter because of Mammoth Cave, one hundred miles south of the city, and Wyandotte Cave, thirty-five miles west of the city in southern Indiana.

At the peak of the cold war, George Kinkead, the civil defense director for Louisville and Jefferson County, designated some six hundred fallout shelters, including the former quarry owned by the Louisville Crushed Stone Company. Each was fully equipped with emergency equipment and provisions. The quarry even had a hospital unit and power generator. The shelters were considered capable of supporting over 600,000 citizens. The Louisville Civil Preparedness Agency became the watchdog that oversaw communications capabilities, coordinating and directing preparations for a nuclear attack. The agency had a staff of seven professionals, two secretaries and two full-time volunteers.

In April 1970, a sixteen-page publication was distributed called the *Louisville–Jefferson County Community Fallout Shelter Plan*, which outlined the available secure locations. The locations of many of these "designated" shelters would come as a surprise today.

Rush Eggleston's "mushroom house."

The quarry, known today as "Louisville Underground," was said to be able to house 100,000 residents. The new Federal Building (1969) became earmarked as a shelter for 22,000 persons. The 800 Building with its three-level underground parking garage had a shelter at the lowest level. Even Waverly Hills Sanatorium had tunnels (with air vents) large enough to hold all patients and hospital personnel.

Many individuals designed and built their own shelters. Perhaps the best known, the structure sometimes called the "mushroom house" was built by Rush Eggleston on the corner of Goldsmith Lane and Masemure Court. The circular core has thick steel walls; the roof and the floor are supported by heavy industrial-grade I-beam girders. Even the roof is built with steel plates. The garage was equipped with a generator to provide power.

When the cold war ended, interest in these shelters waned except for use in weather extremes, chemical spills or domestic violence.

Appendix

Candy Manufacturers in Louisville and Southern Indiana

Company Name	Specialty	Timeline	Location
American Chicle Company	Kis-Me chewing gum		
Baird's		1930s–1950s	New Albany, Pearl Street
Bartons		1965	531 South Fourth
Bauer's Candy	Modjeskas	1889–present	Bardstown Road, Frankfort Avenue; located in Lawrenceburg, Kentucky, as of 2005
Benedict's Restaurant	birthday cakes, candy roses	1888–1934	Fourth Street (Jennie Benedict), between Walnut (Muhammad Ali) and Chestnut
The Bourbon Ball	bourbon candies		1101 Goss Avenue
Bradas & Gheens	Nightingale Chocolates/ Anchor brand	1833–1960s	817 South Floyd
Busath's	Modjeskas	1880–1947	445 South Fourth Street (Anton Busath)
The Chocolate Shop		1920s	Jeffersonville, 400 block of Spring Street

Company Name	Specialty	Timeline	Location
Christ Kraemer's	restaurant, bakery and confectionery	1890s	Third Street
Clark Candies	Pulled Cremes		Merged with Ruddell, 3921 Chenoweth Square
Curtiss Candy Company			1544 Story Avenue
Davis Candy Company/Louis J. Davis		1965	764 South First
Dundee Candy Shop			2212 Dundee Road
Fourth Avenue Candy Shop		early 1900s–closed 1990s	800 East Broadway; also called Old Fourth Avenue Candy Shop; later on Bardstown Road near Eastern Parkway
Hellmueller Baking Company	Chocolate Pickaninny	1927–circa 1940	Webster and Washington Streets
Humphrey's Candy Company			1419 East Washington Street
Indiana Candy Company	Kis-Me Chewing Gum		New Albany
Klein's Confectionery and Restaurant	candies, cakes, crystalized fruits	1865–1920s	456 South Fourth Street
Klotz Confection Company	chocolate turtle		731 Brent
Kremer Candy			F.J. & Sons, 346 East Jefferson
Langin's Candy Shop		1950s	425 West Chestnut
Louisville and Jeffersonville	hard candy		347 Spring Street (Jeffersonville)
Massey-Wyrick Candies			1533 South First Street

Candy Manufacturers in Louisville and Southern Indiana

Company Name	Specialty	Timeline	Location
Mattingly Brothers Candy Company	"Matty-Boy" Peanut Cake	1923–1940	Eighth and Jefferson
Mc's Candies	hard candies	closed in 1990s	New Albany
Menne Candy Company	"Eagle Brand" chocolate	1882–1925	Frank A. Menne, Main and Wenzel
Muth Candy Company		1921–present	526 East Market; 630 East Market
National Candy Company		1924–1970	Fourteenth and Broadway
Parkland Confectionery		1965	1234 South Twenty-eighth Street
Reed's Candy Company	eighteen flavors of ice cream	1930s–1960s	600 block of Fourth Street; 3600 West Market and Fourth and Oak
Ruddell Candy Shop	bourbon candies	1950s	later merged with Clark, 2003 Frankfort Avenue; 3310 Frankfort Avenue
Rudolph's, Inc.		1930–1948	downtown; previously at Rudolph and Bauer
Schimpff's Confectionery	Red Hots, turtles, fish	1850s–present	
Solger's Confectionery Store	marron glacés	1870–1922	T.L. Solger, northeast corner of Fourth and Broadway
The Chocolate Shop		1920s	Jeffersonville, 400 block of Spring Street
The Taffy Pull	taffy	1960s	1324 East Washington Street

Bibliography

"Abraham Lincoln." *Encyclopædia Britannica*. New York: William Benton, 1966.

Angle, Paul M. *Lincoln 1854–1861*. Springfield, IL: The Abraham Lincoln Association, c. 1933.

Arrington, Charles. "Curtiss-Wright Aircraft Factory." *The Encyclopedia of Louisville*. Edited by John Kleber. Lexington: The University Press of Kentucky, 2001.

Birnsteel, Laurie A. "Benedict, Jennie Carter." *The Encyclopedia of Louisville*. Edited by John Kleber. Lexington: The University Press of Kentucky, 2001.

Bischoff, Dan. "Gimme Shelter." *Louisville Today*, August 1977.

Breckel, Charles F., ed. *The Business Builder*. N.p.: 1927.

Caron's Louisville Directory. Louisville, KY: Charles K. Caron, 1887, 1902, 1928 and 1964.

Childress, Morton O. "Workhouse." *The Encyclopedia of Louisville*. Edited by John Kleber. Lexington: The University Press of Kentucky, 2001.

Collins, Kevin. "Kentucky Wagon Manufacturing Company." *The Encyclopedia of Louisville*. Edited by John Kleber. Lexington: The University Press of Kentucky, 2001.

Domer, Dennis, Gregory A. Luhan and David Mohney. *Louisville Guide.* New York: Princeton Architectural Press, 2004.

The Encyclopedia of Louisville. "Charles Farnsley." Edited by John Kleber. Lexington: The University Press of Kentucky, 2001.

French, Robert Bruce. "Music Schools." *The Encyclopedia of Louisville.* Edited by John Kleber. Lexington: The University Press of Kentucky, 2001.

Gatton, John Spaulding. "Only For Great Attractions." Kentucky Historical Society *Register* (Winter 1980).

The Girdler Corporation. Engraved and printed by Manz Corporation, n.d.

"High-Grade Caterers." *Kentucky's Resources and Industries, Louisville.* Louisville, KY: Railway Publishing Company, n.d.

Illustrated Louisville, Kentucky's Metropolis. Chicago: Acme Publishers and Engraving Company, 1891.

Kentuckiana Digital Library Home. http://kdl.kyvl.org. Interview with Charles Farnsley, April 4, 1975.

Kentucky Historical Society—Historical Marker Database. http://migration.kentucky.gov/kyhs/hmdb/MarkerSearch.aspx?mode=All.

Kentucky Metropolis: Illustrated Louisville. Chicago: Acme Publishing and Engraving, 1891.

Kentucky Trailer. http://www.kytrailer.com/DisplayPageContent.aspx?PageID=3208.

Kincaid, Robert L. *Joshua Fry Speed, Lincoln's Most Intimate Friend.* Harrogate, TN: Lincoln Memorial University, 1943.

Kleber, John, ed. *The Encyclopedia of Louisville.* Lexington: The University Press of Kentucky, 2001.

Louisville and Jefferson County Metropolitan Sewer District. "Final Report of Commissioners of Sewerage of Louisville, November 1942; 'Fifty Years of Service: A history of the first half-century of the Louisville and

Jefferson County Metropolitan Sewer District.'" Louisville, KY: Louisville and Jefferson County Metropolitan Sewer District, 1998.

Louisville Board of Trade. "The Fireworks Ampitheatre." *The City of Louisville and a Glimpse of Kentucky*. Louisville, KY: Louisville Board of Trade, 1887.

———. *Louisville Fifty Years Ago, 1873–1923*. Louisville, KY: Louisville Board of Trade, n.d.

Louisville Guide. New York: Princeton Architectural Press, 2004.

Louisville magazine.

Manual of the Woman's Club of Louisville, 1925–26.

Manual's Alumni Web Page. www.manualalumni.org.

"Model Cigar and Tobacco House." *Kentucky's Resources and Industries, Louisville*. Louisville, KY: Railway Publishing Company, n.d.

Nash, Alanna. "Off-Hollywood Newcomer; Bill Girdler's Brief Candle." *Louisville* magazine, December 1971.

The Official Gazette of the U.S. Patent and Trademark Office. Patent 682,243. "Machine for Molding Ice-Cream." Washington, D.C.: U.S. Department of Commerce, Patent and Trademark Office, September 10, 1901.

P. Breen. "William Girdler." www.williamgirdler.com.

Riley, David L. *A Century's Service*. Louisville, KY: Liberty National Bank and Trust Company, 1954.

Rodgers, Jeff. "Movie Theatres." *The Encyclopedia of Louisville*. Edited by John Kleber. Lexington: The University Press of Kentucky, 2001.

Sandburg, Carl. *Abraham Lincoln: The Prairie Years and The War Years*. Boston, MA: Mariner Books, 2002.

Sypris Technologies Tube Turns Division. www.tubeturns.com.

BIBLIOGRAPHY

Thomas, Samuel W., ed. *Views of Louisville from 1766.* Louisville, KY: *Courier-Journal* and *Louisville Times*, c. 1971.

Time. "Gas Fight." January 13, 1930.

Towles, Donald B. "Newspapers." *The Encyclopedia of Louisville.* Edited by John Kleber. Lexington: The University Press of Kentucky, 2001.

Veach, Michael R. "Seagram's Distillery." *The Encyclopedia of Louisville.* Edited by John Kleber. Lexington: The University Press of Kentucky, 2001.

William Girdler. www.racksandrazors.com/girdler.html.

Yater, George. "Prostitution." *The Encyclopedia of Louisville.* Edited by John Kleber. Lexington: The University Press of Kentucky, 2001.

NEWSPAPERS

Atlanta (GA) Constitution
Charleston (SC) Daily Mail
Chillicothe (MO) Constitution Tribune
Daily Kennebec (ME) Journal
Danville (VA) Bee
Decatur (IL) Review
Fort Wayne (IN) News
Fort Wayne (IN) Sentinel
Freeborn County (MN) Standard
Idaho Daily Statesman
Kokomo (IN) Tribune
Louisville Civic Opinion
Louisville Courier-Journal
Louisville Herald
Louisville Herald-Post
Louisville Post
Louisville Times
Nebraska State Journal
Stevens Point (WI) Daily Journal
Syracuse (NY) Herald
Syracuse (NY) Post-Standard

BIBLIOGRAPHY

Ulrichsville (OH) News-Democrat
Zanesville (OH) Sunday Times Signal